POSING TECHNIQUES

for Photographing Model Portfolios

Billy Pegram

AMHERST MEDIA, INC. ■ BUFFALO, NY

Dedication

I would like to extend my appreciation to Dorothy Pegram, and Tom and Dolly Branski for their encouragement, love, and support in helping make this a rewarding career.

Additional thanks to Loa Anderson for her special consultation, especially in sections dealing with the CSI program. I would also like to thank all the demo models: Bethany, Ciana, Iana, Janeen, Kasia, Krissy, Lexie, Lisa, Marisa, Mary, Monique, and Shayn.

Special thanks to: Bikini Bay Sportswear and Swimwear designer Bo of Toronto, Canada; Lana Fuchs from Isis Couture, who provided many of the fashions in the images; hair and fashion stylist Michael Hall of Seattle; hair and makeup specialist Wendalynn Nelson of Las Vegas; and makeup artists Nicci Kelly and Christina Copeland.

Finally, thanks to: Cinch Jeans, *Dusk* magazine, *Headlights and Tailpipes* in Las Vegas, *Luxury Las Vegas* magazine, and *Showbiz* magazine.

Copyright © 2008 by Billy Pegram.
All photographs by the author.
All rights reserved.

Published by:
Amherst Media, Inc.
P.O. Box 586
Buffalo, N.Y. 14226
Fax: 716-874-4508
www.AmherstMedia.com

Publisher: Craig Alesse
Senior Editor/Production Manager: Michelle Perkins
Assistant Editor: Barbara A. Lynch-Johnt
Editorial Assistance: John S. Loder, Carey A. Maines, and Artie Vanderpool

ISBN-13: 978-1-58428-220-4
Library of Congress Control Number: 2007926868
Printed in Korea.
10 9 8 7 6 5 4 3 2 1

Table of Contents

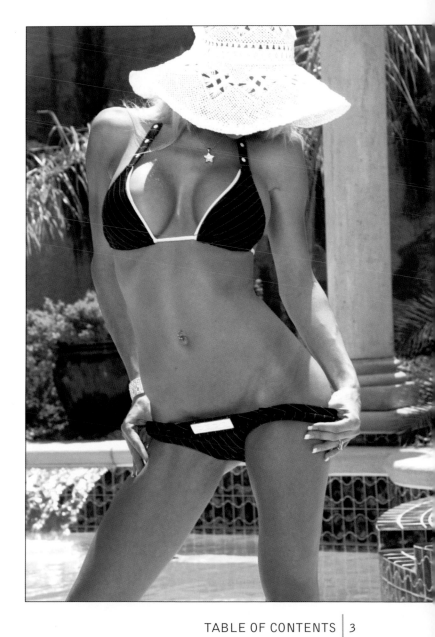

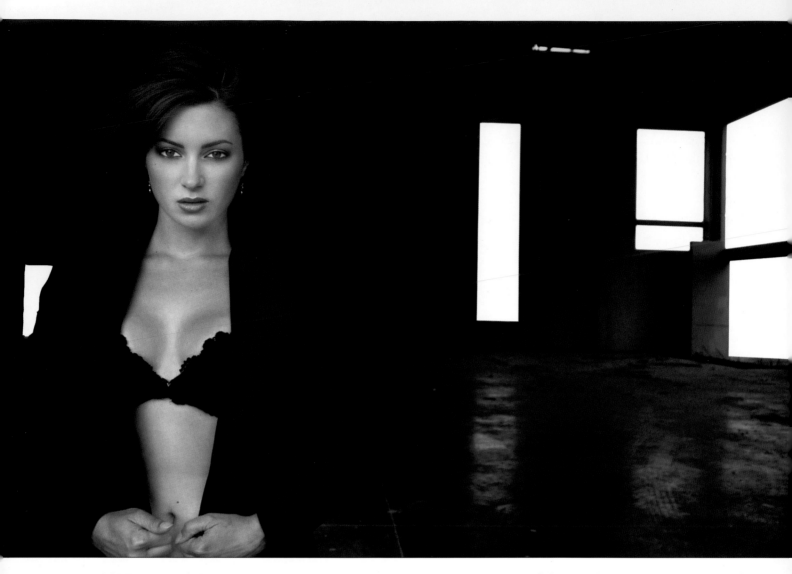

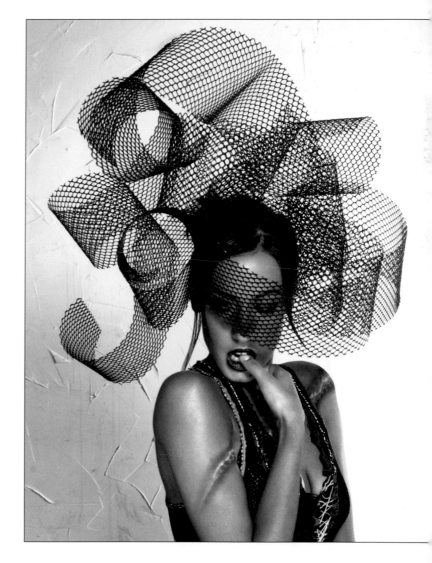

Introduction

THE IMPORTANCE OF GOOD POSING

Over the years, I've realized that there is indeed an art to posing models—an art that all photographers, in order to be successful, must study and develop.

Helping the Model Look Her Best. Beginning models in particular rely on the experience of the photographer to guide them to flattering poses. Even experienced models, although they usually develop a rather extensive repertoire of poses and move gracefully through a series, still need the photographer to fine-tune their poses, emphasizing their best features while minimizing the weaker ones.

Often, a nervous model will simply stand in front of the camera, waiting to be told what to do. If you are an inexperienced photographer, it can be difficult to direct the model—especially since photographers tend to be better at visualizing a pose than communicating it clearly to a subject.

Pleasing the Client. With model photography, there is an additional consideration: the client. This may be a commercial client or, when shooting for a model's portfolio, all of her *prospective* employers.

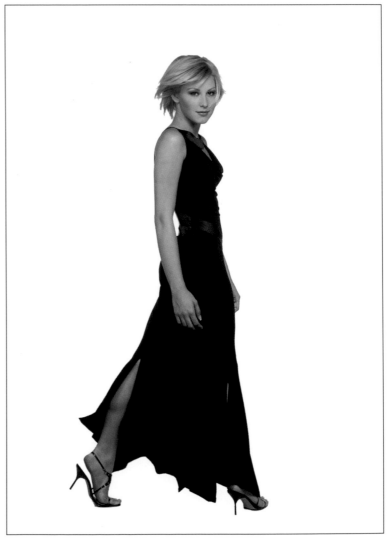

There is an art to posing models, and the only way to master it is through study and practice.

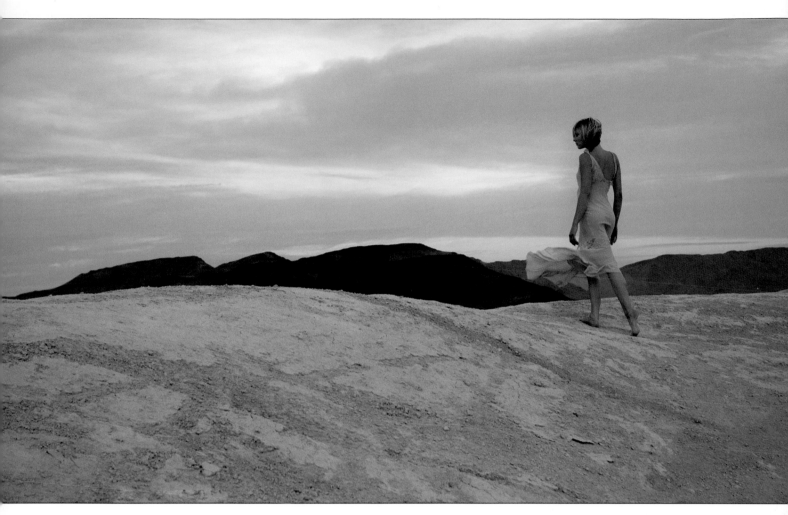

Getting a great model shot is not a matter of luck—it requires patience, skill, knowledge, and commitment.

If the image is being created for a commercial client, the model is often secondary to the product; she is used solely to enhance the mood of the photograph. In this case, the model's pose must force the viewer's eyes to the product or service being promoted. If a model can do this, while still creating an emotional response, then the photograph will be successful for the client or advertiser. Ask yourself: What are we trying to show? Is it a particular item of clothing, something special about the clothing (e.g., a zipper, material, or a design)? What is it that will prompt the viewer of the photo to want to purchase this product?

If the image is being created for the model's portfolio, it must be designed to appeal to the kinds of clients from whom she is hoping to gain employment. These may include designers, magazines, product manufacturers, jewelers, and any other industry where models are employed. In addition, the images must showcase the model's best attributes, conceal any problem areas, and appeal to her own aesthetic sensibilities and personality. Again, ask yourself some questions: What are we trying to show? What will inspire the client to hire this model?

BRITT**BOCKIUS** KEVIN**STEWART** MARVIN**GARRETT** FRED**WHITFIELD** CASH**MYERS** LARRY**SANDVICK** CODY**OHL**

In a commercial image, you need to determine what will prompt the viewer of the photos to want to purchase the featured product.

LEAD, DON'T FOLLOW.
FRED**WHITFIELD**

CINCH

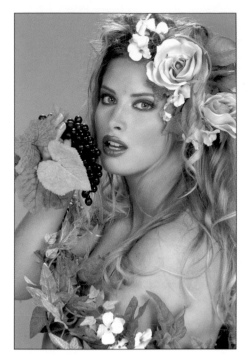

In a model's portfolio, you want the potential client to see something that he can relate to and want to hire her. Variety, as seen in these three images of Ciana, is a key factor in achieving this goal.

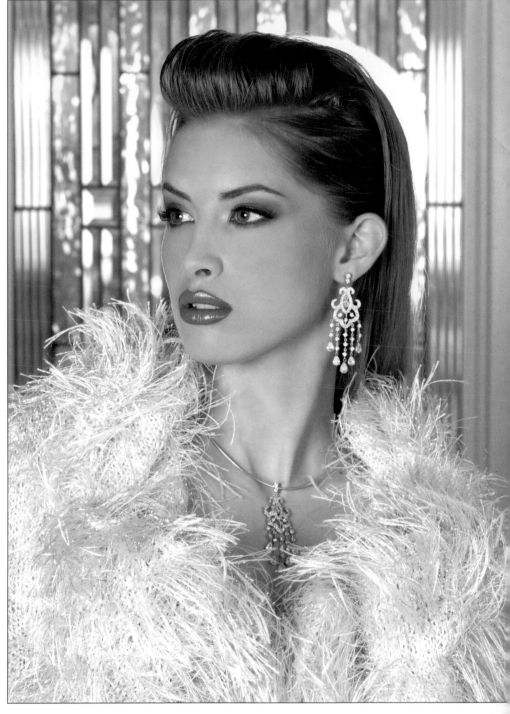

The purpose of creating the model's portfolio is to show a wide range of looks and to feature her best attributes. Ultimately, you want the potential client to see something in her book that he can relate to and, based on that, want to hire her.

THE CHALLENGES OF MODEL PHOTOGRAPHY

As you can imagine, all of this means that getting a great model shot is definitely not a matter of luck. One simply doesn't happen across the

Successful model photography requires a mastery of all the technical aspects of photography, including digital enhancements.

perfect model in the perfect position with the perfect lighting and grab a camera. Creating that flawless, captivating photograph requires patience, skill, knowledge, and commitment. It also requires mastery of all of the other aspects of professional photography.

Technical Changes. No matter how experienced you are as a photographer, there are always new techniques to learn—new equipment, new film and capture methods, and new styles. Your repertoire of techniques must always be changing and suited to the current tastes of the market. This is especially true in the digital age, where technology grows by leaps and bounds with each passing day.

Styling. An additional challenge in working in model photography is that you need to be well versed in all aspects of hair, makeup, and photo styling. Building a team of specialists is crucial in attaining professional status as a shooter. After you decide what you need to emphasize in the photograph, your team (makeup artist, hairdresser,

FACING PAGE—Once you've decided on the look you want, having a team of specialists in place can help you to achieve your goal.

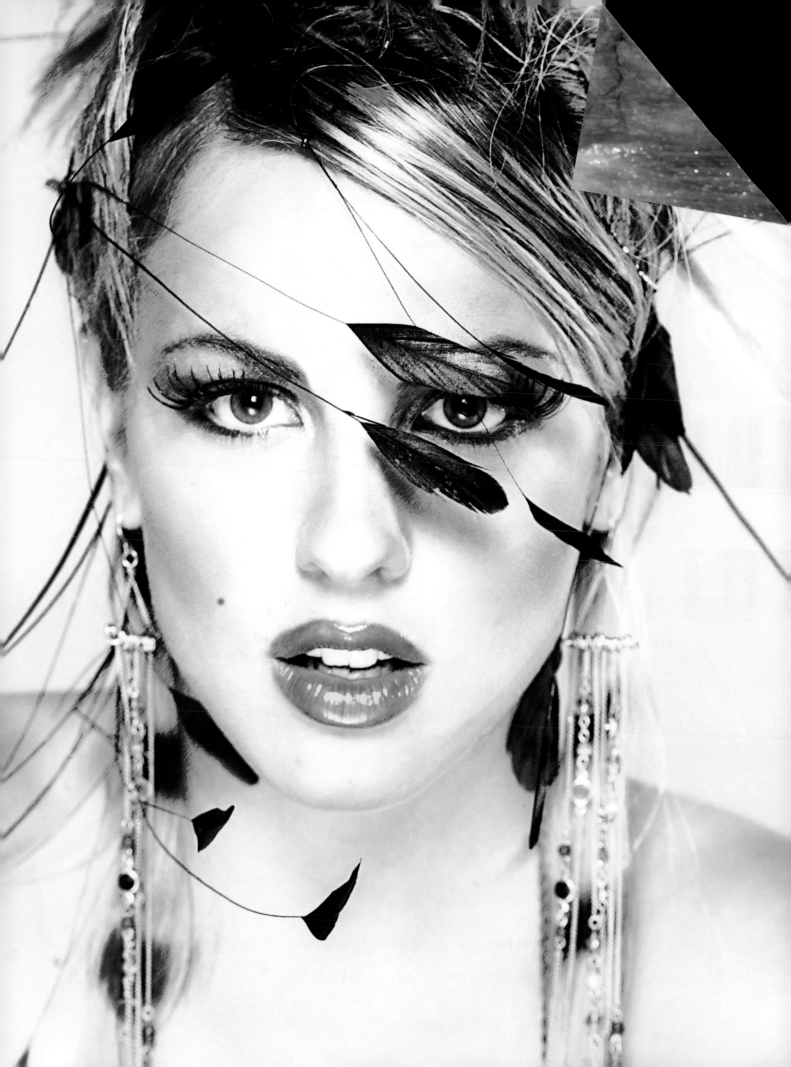

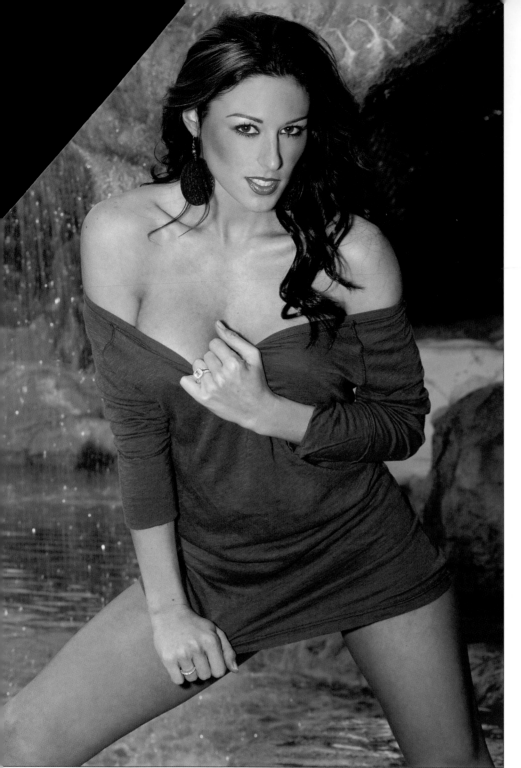

Fashion photography is not just about recording an image, it's about making a creative statement.

Be patient during the
shoot and provide plenty
of positive reinforcement.

and photo stylist) will all need to work together to create the optimal image. Having specialists assist you drastically reduces your workload and adds to the creative process. A good support team that works together frequently can even help an advanced amateur photographer begin to produce top-quality professional work.

Working with People. Fashion photography is not just about recording an image, it's about making a statement. Be patient during the shoot and provide plenty of positive reinforcement. The model

must feel at ease to do her best work. The photographer's responsibility is to create a safe and comfortable environment and to assist her with succeeding in the shooting process.

ABOUT THIS BOOK

This book will help take the guesswork out of posing models and provide you with the knowledge you need to avoid common pitfalls. It will also illustrate a multitude of posing variations and show you how to position models to achieve your aesthetic objectives. Most importantly, it will assist you in developing a foundation from which your own creativity can flourish.

A good support team that works together frequently can help you produce top-quality professional work.

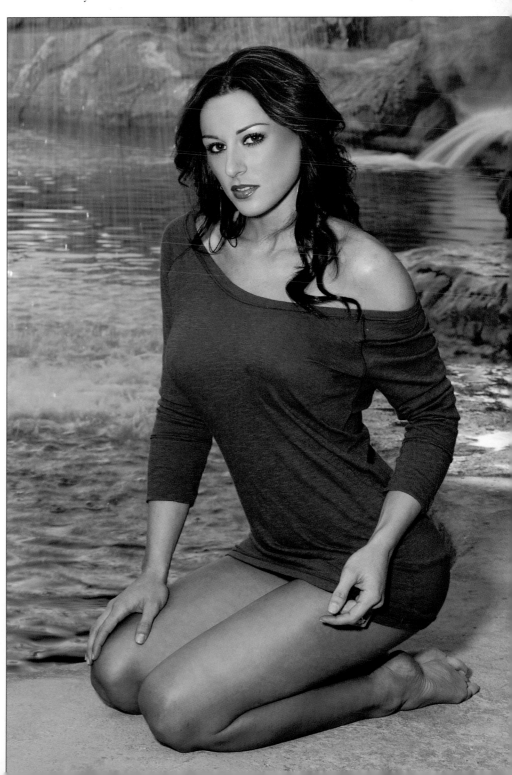

1. Basic Principles

PREVISUALIZATION

Over the years, I have heard many people refer to the photographer's or artist's "eye." This refers to an individual's ability to previsualize a photograph or a piece of art before starting the production process. Previsualization is necessary anytime you work with models. After all, a model is not an inanimate object that can sit there all day. Her job is to communicate feelings and add emotion to the photograph. By planning out your ideas and before the shoot starts, you'll be best equipped to capitalize on the model's abilities.

Emulate the Success of Others. A great source of inspiration is the work of other photographers you admire. Make a resource collection of these samples to help hone your own likes and dislikes. You don't need to copy every detail of another photographer's images to make your photographs successful, just emulate the elements that mesh with your personal vision.

Use Your Imagination. When creating an image, especially when trying to emulate another photographer's work, be sure to look for ways to integrate your personal feelings—your likes and dislikes, loves and passions. Imagination is the most powerful tool a photographer can possess. Technical proficiency can be learned through education, experimentation, and practice, but imagination comes from within. Studying the work of current and past artists and photographers will assist in your imaginative process and help you to establish your own unique style.

When photographing people, the photographer must exert more energy than the model to bring life into the photograph. Ask yourself a few questions before shooting:

> A great source of inspiration is the work of other photographers you admire.

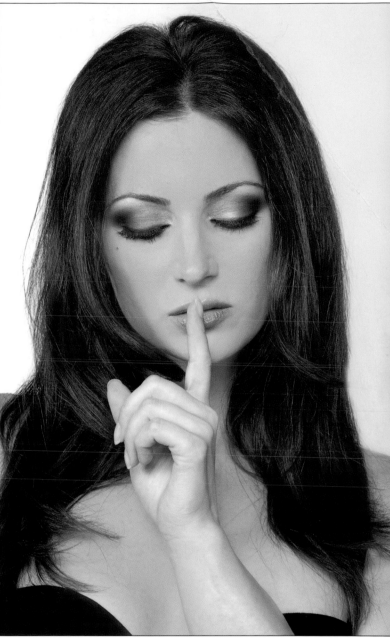

Use your imagination. Once you have a basic concept in mind (like a simple headshot of a model making a "Shhhh!" hand gesture), try some variations by making slight adjustments to the pose or expression.

- What are we trying to show/sell?
- How do the elements of the pose relate to the background, the clothing, or the product?
- What pose is appropriate for the clothing, product, or the desired feeling of the photograph?

Communicate Your Concept. After settling on an idea or concept, you must communicate it to the model before you start working. This will establish your credibility with those on the set and allow the whole team to work in a unified direction. Keep in mind that being in front of the camera can make people nervous, so being clear with your in-

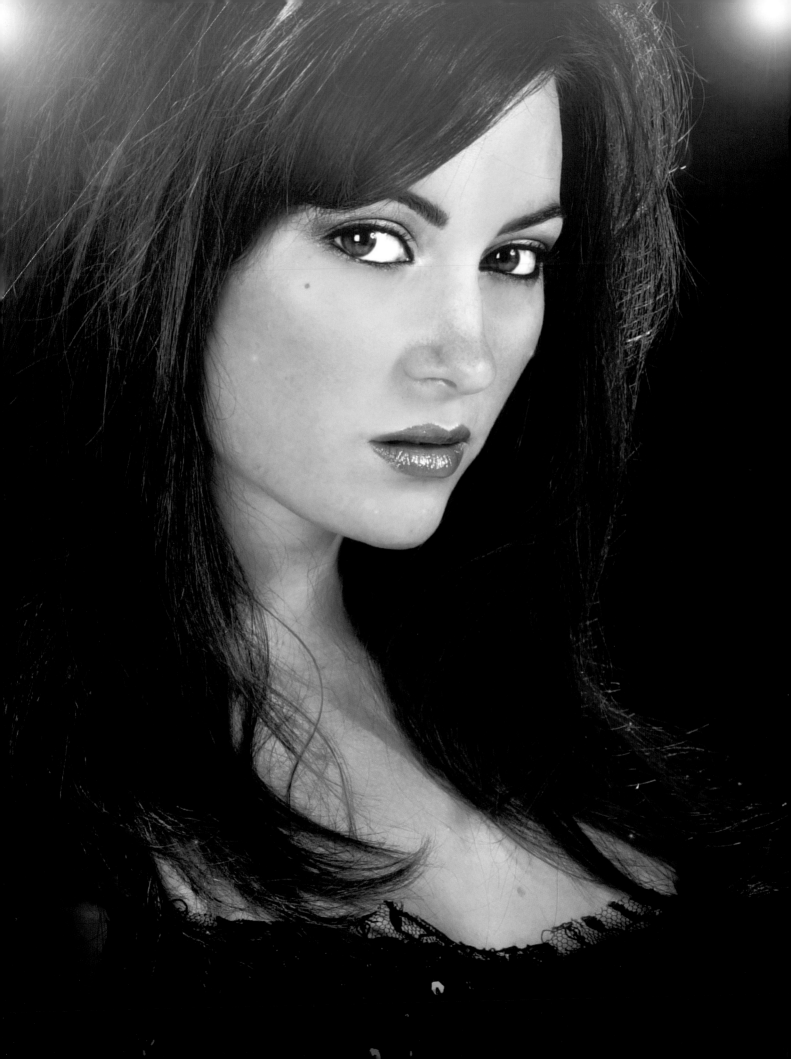

FACING PAGE—In this headshot, your eye enters the frame at the bottom left corner. It then skips to the lightest nearby area—the model's chest. From there, the eye travels up the curved line of pale, exposed skin—from the chest, to the neck, to the face, and right to the model's eyes. In this beauty shot, that was exactly the intended focus of the image.

One way to communicate your intent is to show sketches or sample photos.

structions and making the session professional can increase your chances of success by putting the model at ease.

One way to communicate your intent is to show sketches or sample photographs of the style, the poses, and the overall feel of the photograph you want to create. Another trick is to have someone stand in as the subject and allow the model to look through the camera so she can see what you are seeing and understand the posing. Finally, you may even try having the model pose without the camera in place—that sometimes helps to relieve anxiety about the shoot.

Once the shoot is under way, *don't have the model change poses dramatically for every shot*. Rather, ask her to change one small element per shot—the tilt of her head, the position of her hand, the angle of her hips, etc.

OBJECTIVES

The two main principles governing the creation of a photograph are these: creating flow and directing the eye. Gaining an understanding of these principles is paramount.

Creating Flow. "Flow" is the term I use to describe how the viewer's eye is directed or drawn through the photograph. In the Western world, our eyes are trained to look at the printed page from left to right. Even a child who cannot yet read will follow the words in this direction using their finger. As adults, when we need to quickly scan a page, we automatically glance from the left to the right.

The same basic principle applies when looking at a photograph. The eye will "enter" from the lower left corner. Then, it will search for the brightest thing in the photograph. The arrangement of lines, shapes, colors, and tones in the frame will direct this search—and the photographer must use these elements to control the flow, directing the eye to the intended subject of the image (the product, the garment, the model's face, etc.). For an image to succeed, elements that block the flow of the eye to the desired area must be eliminated.

One of the most important tools for achieving this goal is the positioning of the model's body. For example, the viewer's eye may follow the line of a leg up through the body to the face. Alternately, the body might be posed so that the viewer's eye is drawn up the model's arm to her diamond bracelet. Similarly, the whole body might be posed to draw your eye to the dramatic cut of the gown the model is wearing.

A helpful way to practice achieving the right flow is to look at some photos or magazine ads and diagram the flow of your eye to the sub-

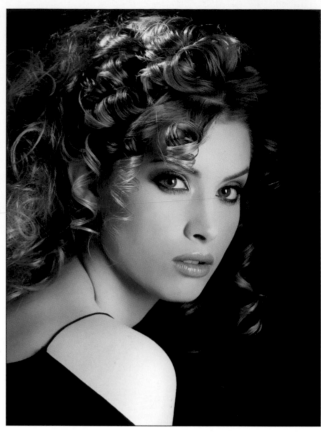

ject of the photo (or to the logo in an ad shot). It may help to turn the image upside down. This makes it less recognizable; instead of a body, the subject is rendered more as a series of shapes and colors. Observing these simple shapes can help you to visualize the flow more easily. Analyze the flow of the photograph upside down, then turn it right side up and see if it still has the same flow. If you're looking at an image on your computer screen, you can also try reversing it from left to right and observing how this impacts the flow. This is frequently done in editorial and advertising images to better direct the viewers' eyes to the image.

Stopping the Gaze. Stopping the viewer's gaze is the objective of creating flow. Where should the eye stop? It might be the client's logo, the detail on a garment, or the eyes of the model—it all depends on the intent of the image. If you look at an image and find that your eye is blocked (i.e., it stops before it gets to the intended subject) or is directed to an unintended area, there's a problem with the flow; your gaze is not directed to the proper place in the frame.

After you have trained your eye to see the flow of a photograph (and stop it in just the right spot), you will be able to previsualize the needed composition sufficiently to design the lighting scheme and pose to meet your objectives.

FACING PAG (ORIGINAL IMAGE)—The model was positioned looking over her left shoulder, creating a line that draws your gaze to her eyes.

LEFT—When training your eye to see the flow of the photograph, flip the photo and then identify the focal points. If the photo is well composed, the focal points will remain the same, although your eye will travel a different path to them.

RIGHT—Photos are frequently flipped in magazines and advertisements in order to lead the viewer's eye to the products. When flipping photos, be sure they do not include any logos or text that will be reversed!

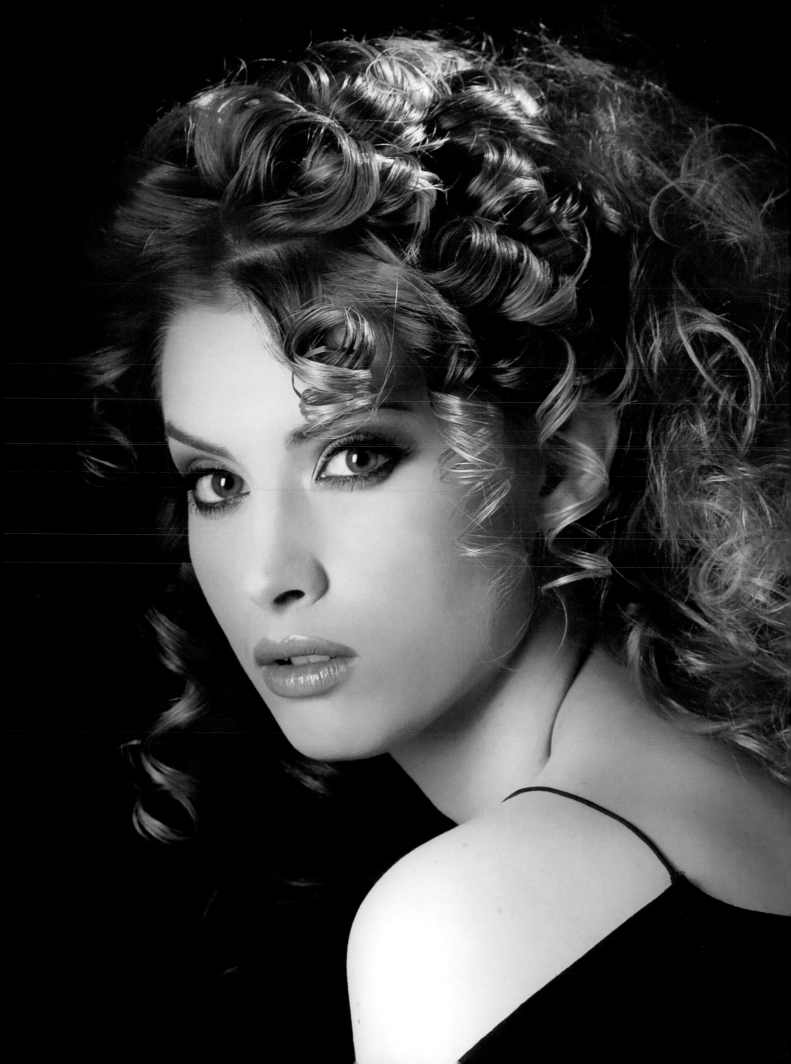

TOOLS

To control the flow and emphasize the intended subject, the photographer must understand the basic tools used to manipulate the path of the viewer's gaze. Some basic elements are: lines, curves, composition and cropping, perspective, and tone/color.

BELOW—The subject of this image is the dress. Notice how your eyes move right to this area and remain locked on it, taking in the details of its color, style, and texture.

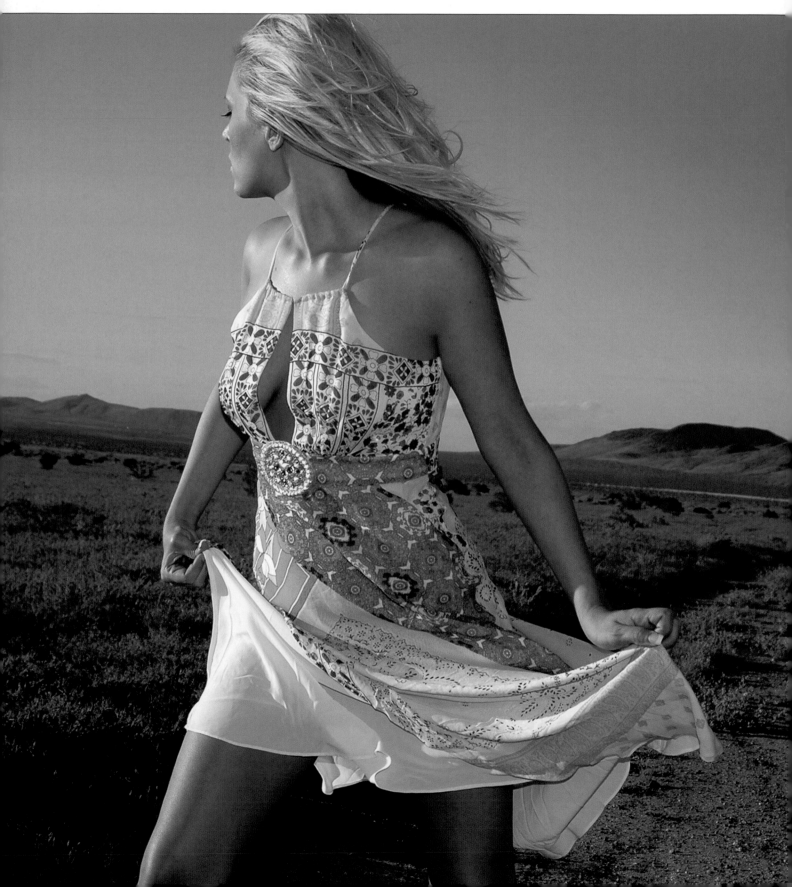

RIGHT—Where does your eye stop in this photo? It enters the frame at the bottom left, follows the strings of the electric bass up to the bright daisy, then continues straight up to the subject: the famous Las Vegas welcome sign.

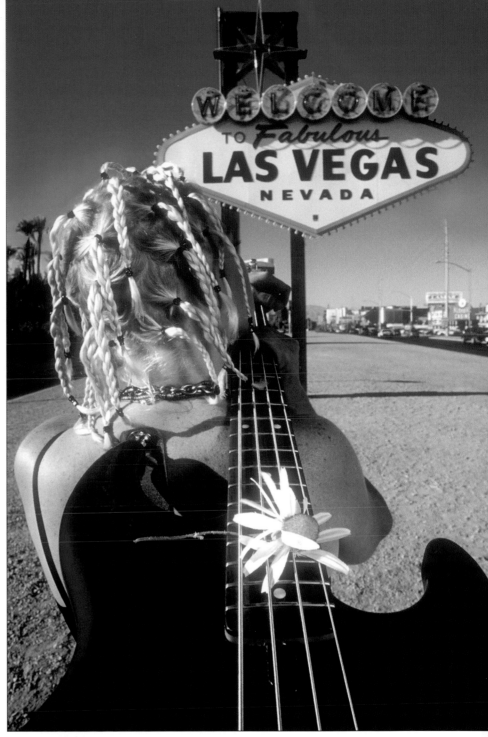

Straight Lines. Straight lines give the photo a structured appearance, which is most often used when a strong, commanding aura is needed. Among straight lines, diagonal lines are more dynamic than vertical or horizontal ones. Vertical and horizontal lines, however, can be good for grounding an image, providing contrast to curves, or lending a sense of solidity.

Curves. Curves tend to be more elegant and stylish than straight lines. They also create a considerably softer look when used in posing. There are two varieties of curves: the C and the S. Both will be discussed in greater detail in chapter 2, where we will look

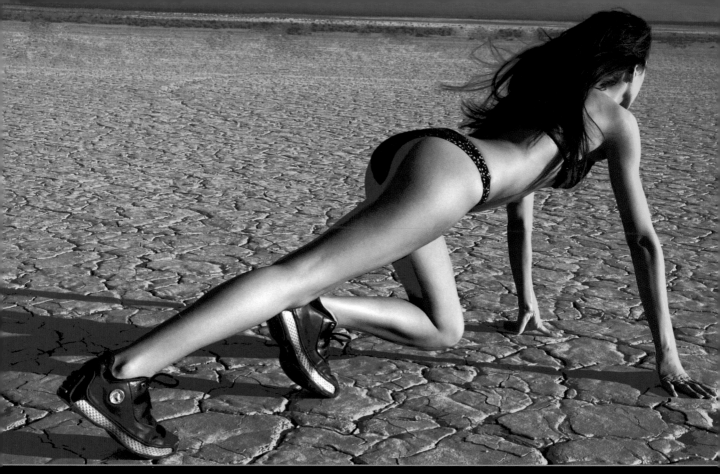

FACING PAGE, TOP—Here, the straight line of the model's body creates the impression that she is a skilled athlete who would be a formidable opponent.

FACING PAGE, BOTTOM LEFT—The long, straight lines of the model's legs in this image form a strong, symmetrical frame for the classic car in the background.

FACING PAGE, BOTTOM RIGHT—Straight lines will usually be introduced automatically when you decide to include architecture in your image.

BELOW—Notice the use of S curves in both the model's body and the road in the background. RIGHT—It's helpful to pose your model so that your photographs will appeal to many potential buyers and offer a number of potential cropping options.

at posing the body. The S curve, in particular, is a beautiful and graceful form that is always pleasing to the eye (see below and next page). The Renaissance masters knew this was the most pleasing position for the female body and used it extensively in their paintings. Its appeal hasn't been lost on today's advertisers, either—notice, for example, how many automobile commercials are shot with roads that form a sweeping S curve across the screen.

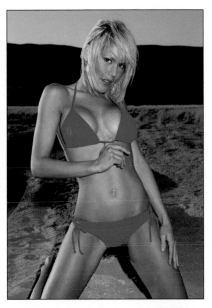

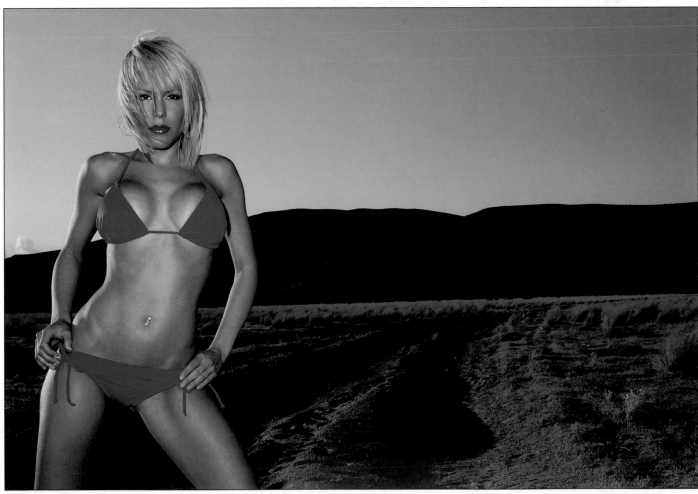

LEFT AND FACING PAGE—Here are two examples of posing the model's body to create an S curve in the frame. We'll look at this pose in greater detail when we get to chapter 2.

Composition and Cropping. Composition is the term used to describe the placement of the subject in the frame and the overall visual interplay of all the elements within the frame.

There are many theories about how to compose the most powerful image, but one guideline that will serve you particularly well in model photography is the Rule of Thirds. According to this rule, the frame is divided up into thirds (imagine a tic-tac-toe grid superimposed over the frame). These lines indicate good places for a subject within that frame.

There are many theories about how to compose the most powerful image . . .

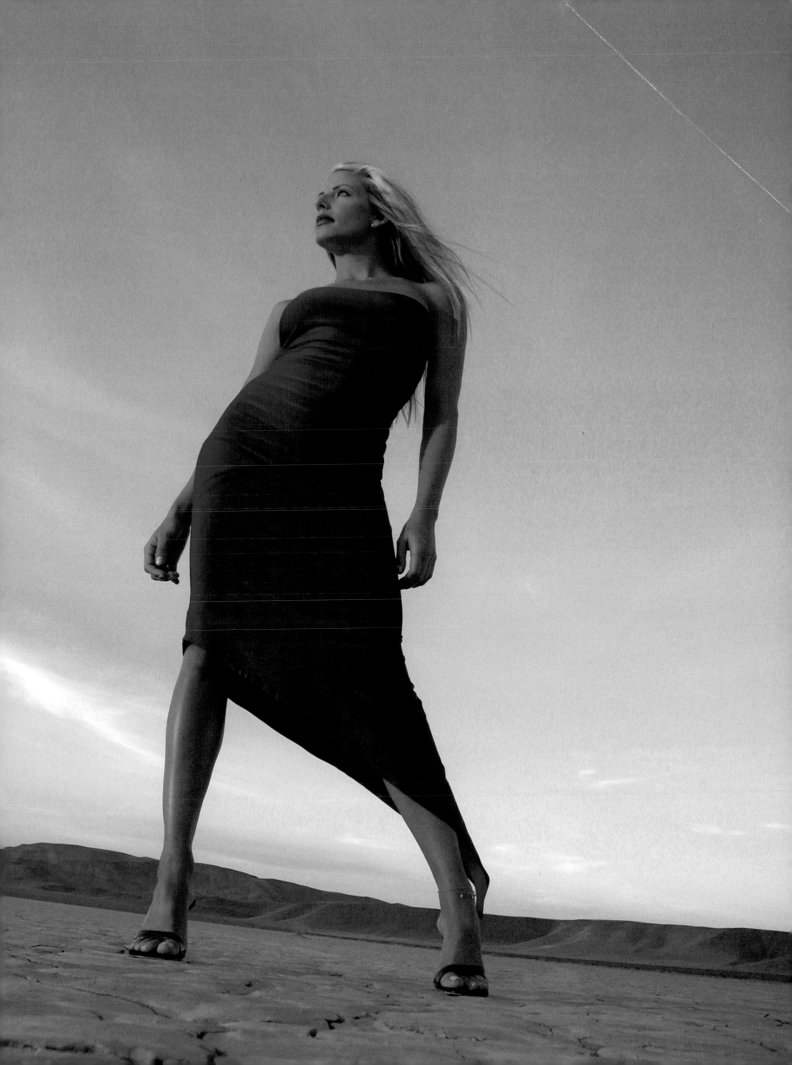

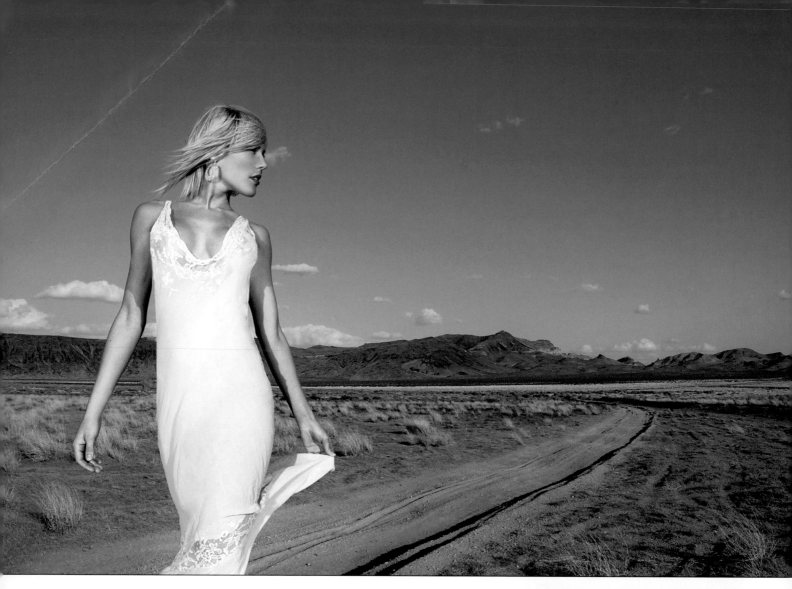

Placing your model according to the Rule of Thirds can create a very pleasing composition. Here, the model is posed to direct the flow into the empty space to the right. This provides magazine editors and art directors with an area for text and captions. Notice that the image could also be successfully cropped in a number of ways.

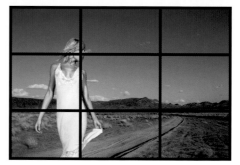

The intersections are considered particularly ideal positions for a subject. In most portraits and beauty images, this means that the subject's face (in a full-length shot) or eyes (in a headshot) will be placed somewhere along the top one-third line. In other images, the product or logo may be placed along one of these lines to emphasize it.

A particularly practical aspect of applying the Rule of Thirds when composing your images is that it tends to leave you with an open area that is suitable for placing ad copy. The model's body can also be posed to lead the eye directly to this text. (*Note:* When shooting for a commercial client, the art director will normally give you a sketch or a layout for the ad. I suggest you shoot this exact layout, then respectfully make any suggestions you might have for small variations to

Here, the client has plenty of room to add text in the top-left corner of the image. Notice that the model's head is placed close to the product and tilted toward it. This creates a feeling of intimacy.

create in some additional photos. It may seem like overkill, but the client will understand how hard you will work to get the right shot.)

When composing an image of a moving subject be sure to leave some extra space on the side of the image toward which the subject is moving. For commercial projects this creates the flow of the photograph and gives the editor a great place for copy.

Perspective. Perspective is another tool that can be used to direct the eye. For example, you can use a long lens (200mm or more) to

help you separate the subject from the background by reducing the depth of field. For commercial and fashion work (see chapter 4), I find that a wide-angle lens (28mm or less) can combine with a dramatic pose to create impressive images. There are very few pitfalls when using wide-angle lenses combined with reduced depth of field and dramatic poses, because the viewer of the photograph visually understands the dramatic effect.

Tone and Color. Earlier, I mentioned that the eye enters a photograph at the lower-left corner, then looks for the nearest bright area. This is because contrast draws our eye, and a bright area is usually an area of high contrast. (*Note:* The exception to this would be in a high-key image, where the dark areas of the shot are what provide contrast with the otherwise light tones throughout the frame.)

Another element that draws our eye is color. Highly saturated, intense colors will draw the viewer's eye more than pastel or subdued ones. Similarly, warm colors (like red and yellow) attract more attention than cool colors (like blue and green).

In the first image (top left), notice how there is tension between the edge of the photograph and the model. In the second image (top right), the centered subject is too static. In the final image (above), on the other hand, the model has plenty of room to ride into—and there is plenty of space for an editor to place copy.

FACING PAGE—Using a wide-angle lens enlarged the model's foot, which was extended out toward the camera. It's an unusual perspective used to create an unusual image—and it's perfect for accentuating these chunky platform shoes.

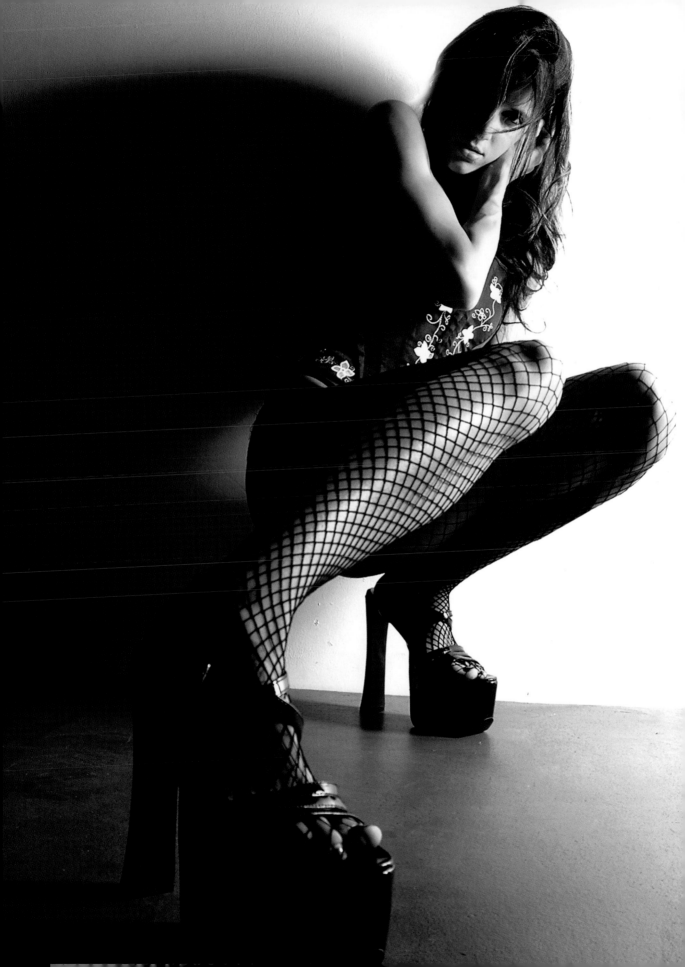

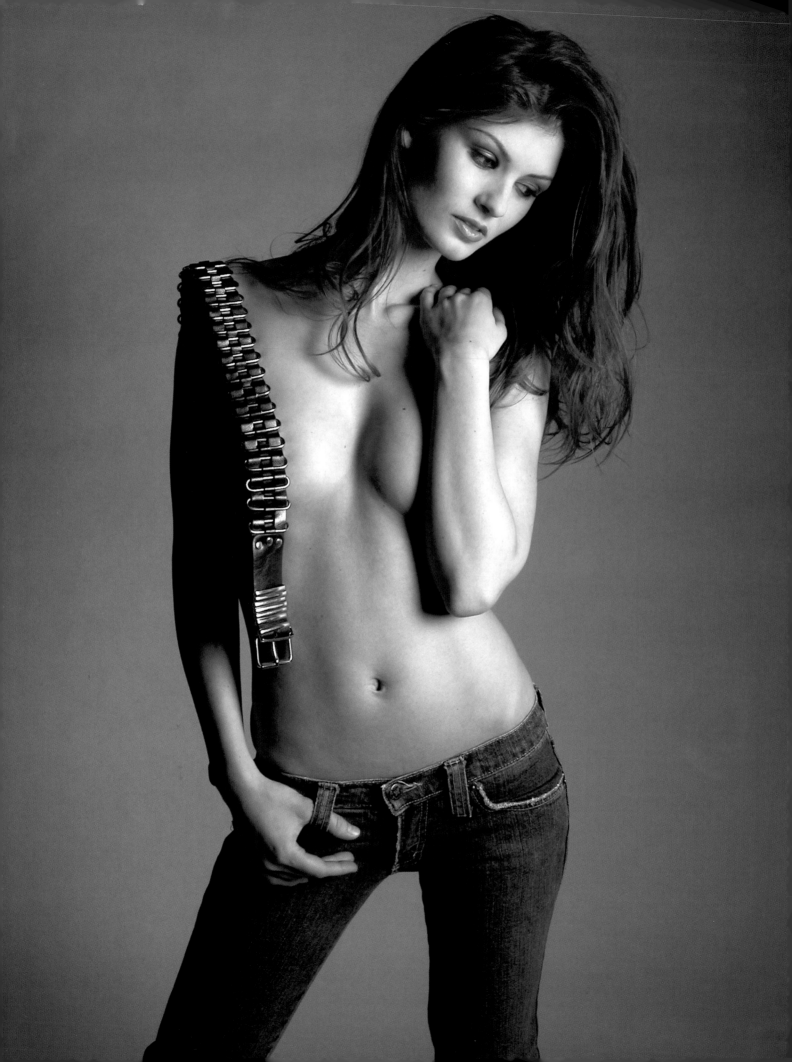

Posing. As you've probably guessed by now, the posing of the model's body is one of the critical elements in successfully directing the viewer's eye. Ensuring that the pose accomplishes this successfully is the responsibility of the photographer. For example, a well-executed leg pose will draw the viewer's eye up the leg, through the body, and to the face—which is the ideal. Incorrectly posed, however, it can easily misdirect the eye up the body to a portion of the anatomy not intended as a point of focus by the model, client, or photographer.

In the following chapters we'll look at this critical element in detail, providing ample guidelines for avoiding problems like this.

FACING PAGE—In an image where most of the tones are dark, the eye tends to seek out light areas.

BELOW—In an image where most of the tones are light, the eye tends to seek out dark areas.

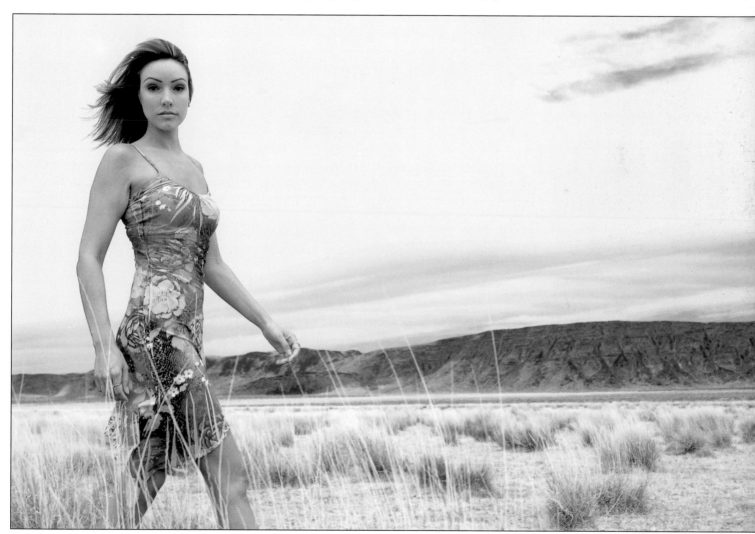

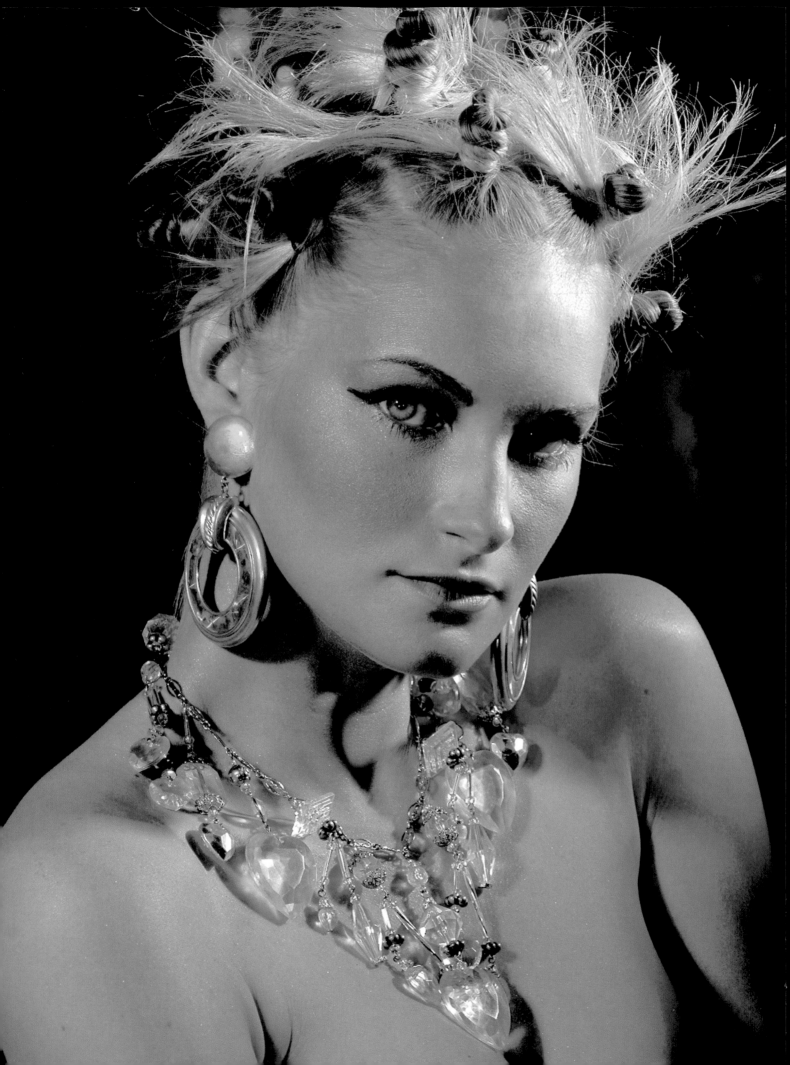

2. Posing the Body

THREE BASIC RULES

Whatever type of pose you choose, there are three basic guidelines to keep in mind:

1. The spine should never form a vertical line
2. The shoulders should never form a horizontal line.
3. The hips should not be square to the camera.

The reason for the first two rules has to do with lines. As you'll recall from the previous chapter, vertical and horizontal lines produce a static, rigid feel in an image. That's why it's better to use the shoulders and spine to create diagonal lines.

The reason for the third rule is that the body looks widest when facing the camera directly. This is not how most female subjects want to see themselves! Turning the body so that the hips are slightly angled will make it appear thinner—a much more flattering view.

Are there exceptions to these rules? Of course. Sometimes you may want to show a model with squared shoulders to convey a very direct, intense look. Or, you may have a very thin model whose slim curves are better rendered when her body is square to the camera. For the majority of images, however, these rules will serve you well.

POSTURE

When a model slumps, it accentuates the shoulders and leads to the "turtle" effect (where the subject doesn't appear to have a neck). It also makes the bustline appear to sag.

The body looks widest when it is facing the camera directly.

FACING PAGE—Posing the model so that her shoulders create a diagonal line produces an more interesting image than if the shoulders were perfectly horizontal.

To straighten a model's posture, have her imagine a string attached to either the center of her chest or the top of her head. Then, ask her to pretend that someone is pulling that string up to the ceiling. This straightens the spine upward, almost to the point of arching the back. It will lengthen the neck, lower the shoulders, firm the bust, and create a much more pleasing photo.

Some models also have a tendency to hunch their shoulders up toward their ears. This is not a good pose, as it also creates a "turtle" effect. Keep a good distance between the shoulders and the ears. This will make the neck appear longer as well.

LEFT—Too many photographers allow the models to slump, resulting in the emphasis being placed on the breasts and the negative space between the neck and the chest. This does not present the model at her best.

RIGHT—Good posture leads to a much better image.

CSI PROGRAM: A STARTING POINT

A photographer must understand the basics of posing each part of the body and be able to recognize the problems inherent in each area. While I don't recommend memorizing thousands of poses, it is helpful to recognize a few basic starting points for posing the human body.

History and Purpose. Years ago, a former model turned teacher named Loa Andersen created the CSI program to teach prospective models how to pose for the camera. This idea was based on methods taught by early European artists. Today, the poses used in her origi-

nal photographs are considered stilted, stiff, and old-fashioned. Yet, the basic idea of the CSI program (named for the three major poses it identifies; see below) is still valid for photographers who wish to develop their posing skills. The program also enables a beginning model or photographer to analyze and re-create a pose selected from a magazine or catalog. Furthermore, it helps photographers to determine how the pose affects the focus and overall flow of a photograph.

Diagramming a Pose. The CSI program begins with learning to diagram a pose. First, a line is drawn through the shoulders. Second, a line is draw across the hips. A third line is then drawn from the center of the shoulder line to the center of the hip line, creating the body line. Next, a fourth line is drawn from the center of the body line to the foot that has the least weight on it. The fifth and final line is drawn from the center of the shoulder line to the center of the head mass.

The C, S, and I Poses. The diagrammed lines will create either a C, an S, or an I—hence the name of the program. If you pick up a catalog or magazine, you'll see that many of the poses used do, in fact, loosely fall into one of these categories. For those that don't, the act of diagramming will show how the pose was created—which shoulder was dropped, how the hips were angled, and where the weight was balanced. Knowledge of these factors will simplify the process of creating a similar pose when working with your own models.

Additionally, the CSI program categorizes foot positions. This is especially useful when shooting for a catalog where space is at a premium and several models will be shot together (see page 96). In the first position, the feet are close together. One faces the camera, while

Here are the three basic poses in the CSI program. As you can see, the lines form the letter shapes that are used to name each pose. The S pose is considered by many artists to be the most graceful and attractive position for a female body. Many of today's most contemporary poses are softer versions of this basic pose.

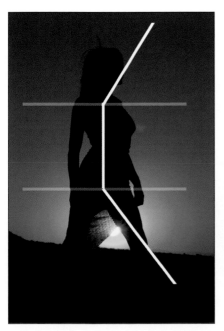
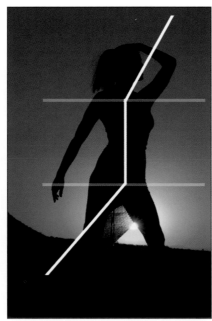
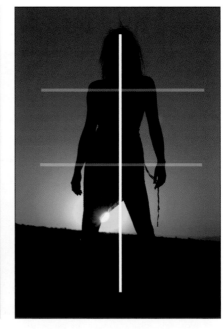

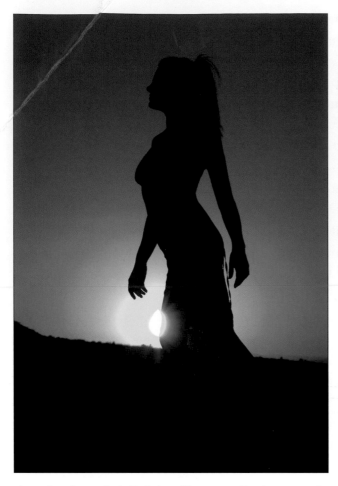
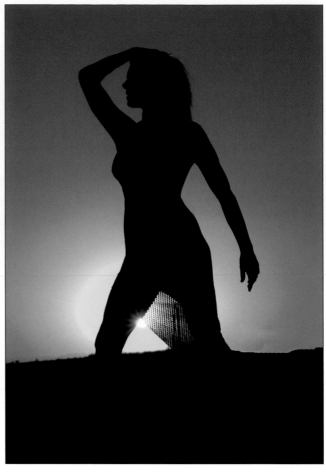

the other is angled slightly off camera. In the second position, the angled foot is pushed outward from the body. In the third position, the same foot is extended even farther.

Foot Positions. In all foot positions, the model's weight is held back over the base foot and the hips are angled in line with the base foot. This slims the hips and enhances the waist. The shoulders are not angled, but are fairly straight to the camera, which also makes the waistline appear smaller.

The Crossover and Open Poses. Additionally, the CSI notes two "walking" poses that are very useful for showing movement. The first, called the crossover pose, requires that the presentation leg (or the leg closest to the camera) be crossed over the back leg, showing the line of the buttocks. For this pose, the body must be stretched upright with the back slightly arched. The line of the back arm and the turn of the hand should also follow the line of the buttocks.

In the second walking pose, called the open pose, the opposite is true—the presentation leg is extended out from the torso, leaving the body more "open." Add an electric fan, and the feeling of movement is guaranteed!

In the crossover pose, the presentation leg (or the leg closest to the camera) is crossed over the back leg. In the open pose, the presentation leg is extended out from the torso.

Years ago, a model was expected to create a notebook of poses torn from fashion magazines, diagram each one, then practice re-creating the poses in front of a mirror. Then, she was taught to close her eyes to "feel" the pose so that she could assume it perfectly without the benefit of the mirror. Finally, when the model had memorized forty or so poses, she would string them together like pearls. The idea was to teach the model to move gracefully and smoothly from one pose to another.

The CSI program may seem to hint at this old-fashioned method, but the photographer who understands the system will find it a very useful tool when faced with a beginning model who just stands in front of the camera like a deer caught in the headlights and says, "What should I do?" Also, if you are trying to help a new model develop into a professional, being able to instruct her in the CSI program will be an asset.

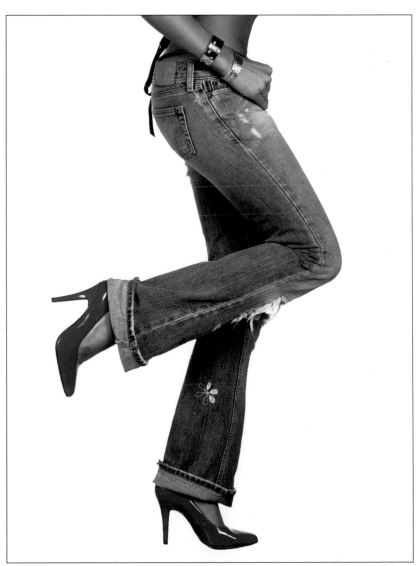

Against the subdued sepia tones in the rest of the frame, it's the red shoes and colorful details on the jeans that stand out in this photograph.

Remember, a photographer is expected to be able to provide helpful suggestions! Having a repertoire of standard poses in your head allows you to guide a model more easily. And that's what the CSI program is—a starting point. It is not necessary (or wise) to stick to standard poses, nor should you always copy poses developed by others. These building blocks are useful, however, as a means for training your eye and assisting the beginning model.

FEET AND ANKLES

The feet are rarely shown in a photograph except when shooting a particular product, such as shoes. However, selecting a good pose for the legs and feet is vital when creating a full-length shot or a shot where the model is one element in a wide image. The feet and legs contribute so much to the overall feeling of the photograph—from the tilt of the hips, to the position of the feet, to the casualness of the stance, or the relaxed angle of a seated model.

A good way to learn how to pose the feet and legs is to tear out photo-

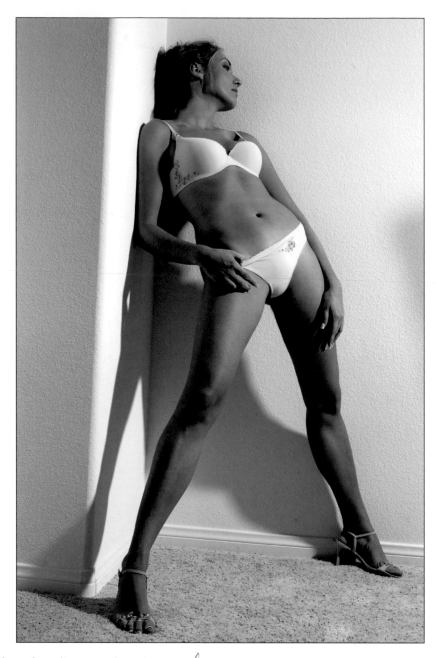

When photographing a model, I always ask her to show me a heel. This ensures that the viewer is seeing the front of one leg and the profile of the other.

graphs from magazines that you like, then draw lines on these images indicating where the bones are positioned in the model's legs. (As noted above, this is a good exercise for posing the rest of the body, too.) Then, step back and evaluate the feel of the photograph. Does the position enhance this feel?

Show One Heel. Legs and feet are rarely shown straight on. When I am shooting a model, I constantly ask her to show me a heel. Even when I am cropping the feet out of the photo I have the model make sure that one heel is always visible to the camera. This ensures that the viewer is seeing the front of one leg and the profile of the other. It also forces the model to position her hips at an angle to the camera. Try

to avoid shooting the model standing flat footed. Showing the feet with the heel raised adds height to the model, makes her legs look more toned, and creates a more graceful attitude.

There are three rules I stress about a model's feet. One, don't cut them off at the ankles. Two, if showing the feet, have the model point her toes. Three, don't show the bottom of the foot.

Cropping. Cropping must be done carefully. The general rule is not to crop at a joint; this creates the feeling that the extremity has been amputated. If a full-body shot is required, show the feet. Nothing is more unbecoming than cropping a model off at the ankles. If it is necessary to eliminate the feet, crop halfway between the knee and ankle (mid-calf) or between the knee and the hip (mid-thigh).

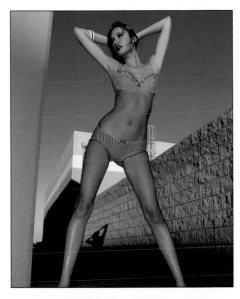

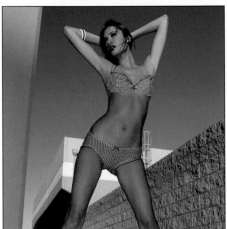

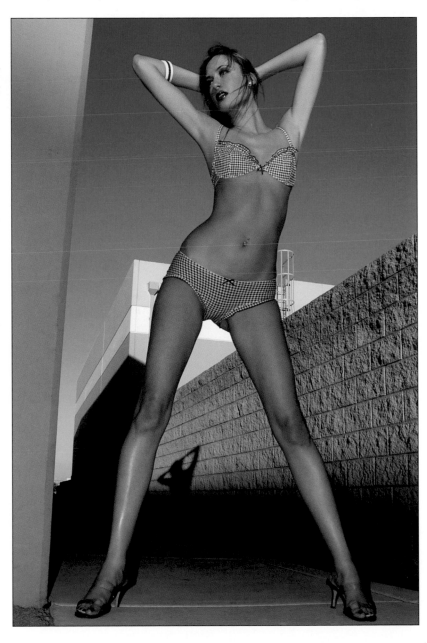

When a full-length image is called for, it's best to show the feet (right). If you must crop the image, however, avoid cropping at the ankles (top) or knees (bottom). Crop mid-calf or mid-thigh instead.

Point the Toes. When a model points her toes, the foot instantly forms an extension of the leg. This makes the legs look longer, slimmer, and more toned. It also looks much more graceful than a flexed foot. This rule applies whether the model is standing, sitting, or laying down for the pose.

When showing the feet in an image, having the model point her toes creates a more toned and graceful appearance.

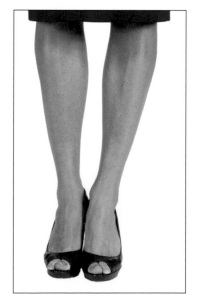 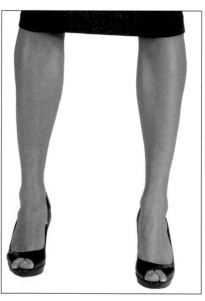 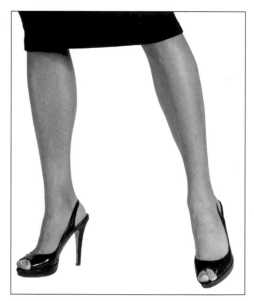

In the first two photos, the model's feet are both pointed directly toward the camera. This is not an attractive pose. In the third image, one heel is visible and the extended toe is pointed. This could work depending on the position of the upper body.

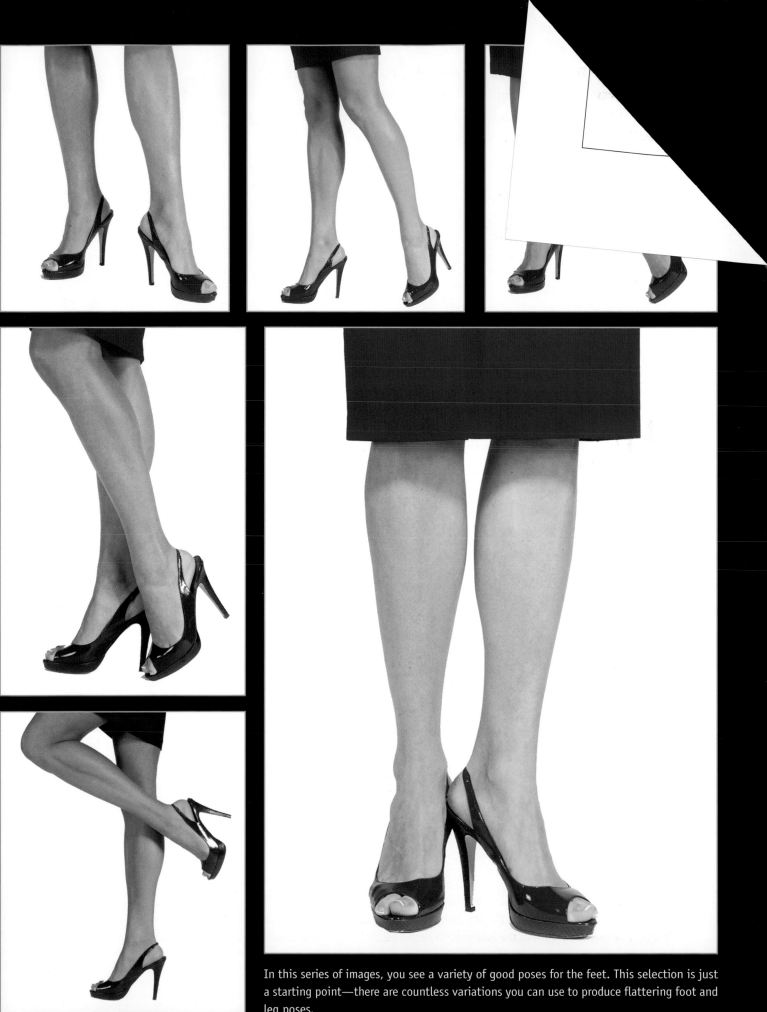

In this series of images, you see a variety of good poses for the feet. This selection is just a starting point—there are countless variations you can use to produce flattering foot and leg poses.

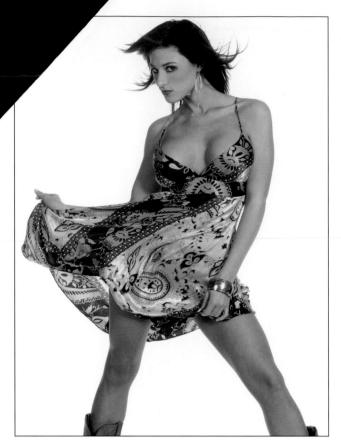

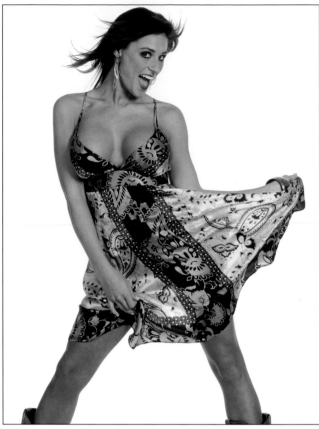

Hide the Bottoms of the Feet. I have yet to see an attractive photo of the bottom of a model's foot—whether they are barefoot or in shoes. Often, shoes will show wear and tear on the bottom, and that's *not* attractive. Even with a seated model, try to position her so that the bottoms of her feet do not show.

Slimming and Lengthening the Legs. Legs appear to be more toned when the muscles on the outside of the thigh and calf are flexed. This can be achieved by directing the model to stretch the presentation leg out, removing the weight from the toe.

To make the legs look longer, you can also put the model on a stage and shoot from a low position, looking up toward her. In my studio, I always have the models on an 18-inch stage. This gives me the flexibility to shoot the model straight on without being on the floor, or to shoot up and create the illusion of a taller model.

As noted above, when the legs are photographed straight on, it makes them appear thicker. Direct the model to show one heel. This gives each leg a separate and distinct position, which makes them look thinner and more graceful.

Finally, if the legs are tight together, it makes the body appear as one solid block and, therefore, thicker. Separating the legs will create a much thinner appearance.

In these images of Mary, we've used a wide stance to create a solid base for the pose. A fan adds a little more energy to the shot.

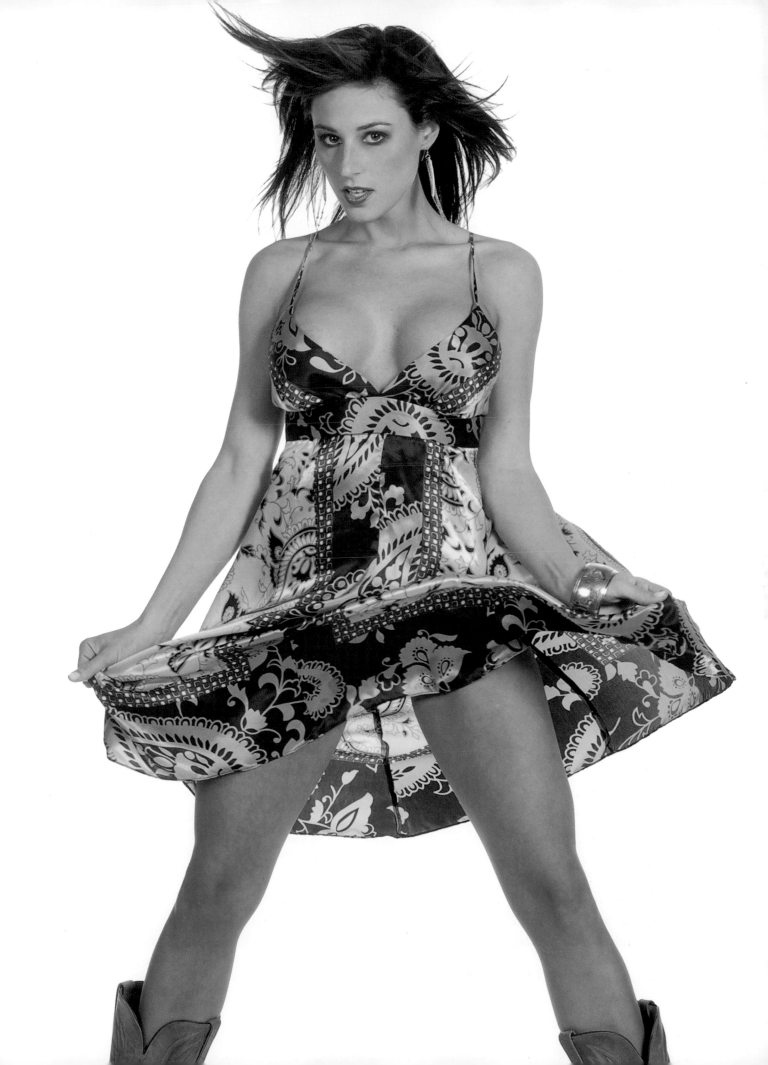

Help for Beginning Models. When a beginning model seems to be struggling and lacking confidence, have her spread her feet to create a strong, sturdy base, then rock from side to side. If you place a fan on her, she will look natural and will project high energy. This wide stance also will make her hips appear thinner, as it is easier for her to rotate her hips away from the camera.

A simple variation on this is to have the model turn her back to the camera, stand in a wide stance, then push off with one foot and swing toward the camera. The movement will end her struggling. Also, have her swing her head forward quickly. This is a great opportunity to catch her hair in motion.

Another option for a model who is struggling is to have her adopt a basic crossover pose (see page 36). In this pose, have the model shift her weight back and forth as if rocking. This will help her break free of static, stationary posing. It will also distract the model from her awareness of the camera; she can direct her thoughts to the movement instead.

HIPS AND DERRIERE

Rear View. When shooting a rear view, models have a tendency to lift the hip closest to the camera. This exaggerates the derriere and the front leg, making them look larger. In most cases, reversing the weight will show a more pleasing shape. However, be aware that either pose

When working with a model who has exceptional features (here, her rear, legs, and midsection) help her create special images that emphasize these attributes. When a client views her portfolio, they will remember these features—especially if they are pertinent to the job. Also, when a client hires a body-part model, knowing that she looks great from many angles is important, so it helps to provide a variety of poses, especially for catalog work.

When shooting a rear view, models tend to lift the hip closest to the camera, making it look larger, as seen in the image on the left. In the image on the right, her hips are thrust away from the camera for a slimmer look.

can be used to an advantage, depending upon the model's figure. There are times that it is desirable to show a larger hip.

Seated Poses. If a model sits flat on her buttocks, the hips and thighs tend to flare out, making them look heavy. Direct the model to roll to the hip nearest the camera to offset this effect. Adjusting her position in this way shifts more of her weight behind her and away from the camera.

Raise One Foot. Have a model place one foot on a sandbag to raise one hip. This will eliminate having both hips along the same horizontal line. Pair this with a pose that puts the hips at an angle to the camera and you will create a much more flattering appearance.

HANDS AND WRISTS

Importance of the Hands. How important are the hands? Very. If you think otherwise, keep your eyes open the next time you're talk-

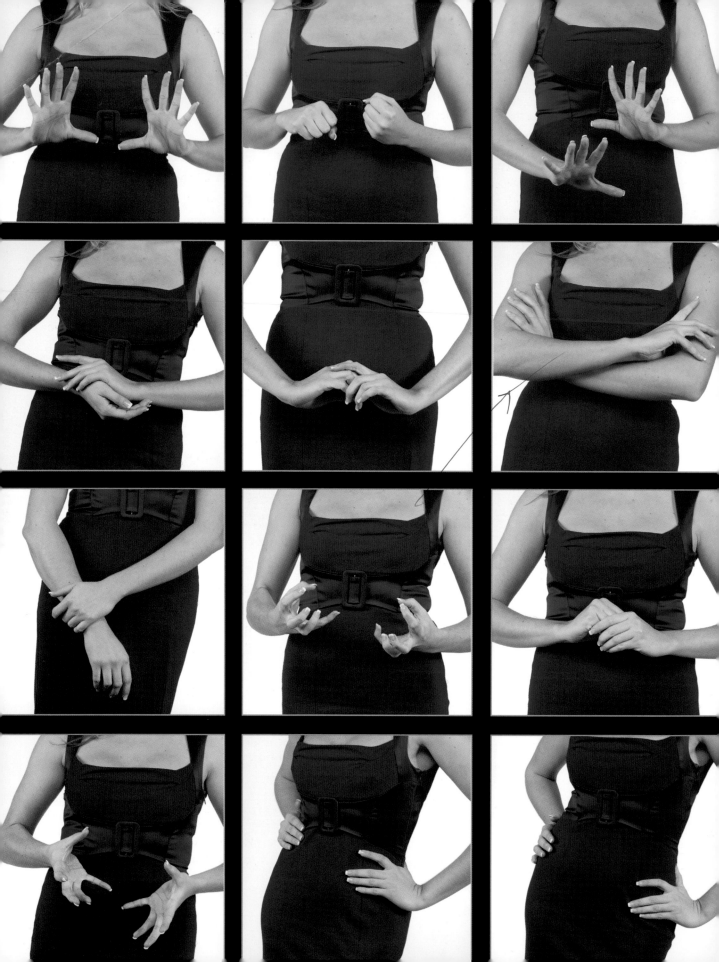

FACING PAGE—The position and attitude of the hands are very important in communicating the emotional feeling of the photograph. When I teach beginning models and photographers posing techniques I use several exercises to enforce how valuable the hands are in creating the mood. My favorite technique is to use two mat boards to cover the model except for the hands. Then I ask the model to show me different moods just by using her hands. Notice how easy it is to feel this model's emotions and to distinguish the different emotions conveyed.

Spread fingers create a distraction in the frame.

ing to a group of people. You'll quickly see that hands are used extensively to add emotion and interest to the words that are being spoken. That makes them an important part of the process of communication. Because of the importance of hands in our daily lives, a viewer's eyes will always look at the hands in a photograph to see what they are communicating.

When teaching a group of beginning models, I have one of the models cover her face and body so that all the group can see is her hands. Then I ask her to demonstrate anger, love, impatience, fear, reverence, and various other emotions using only her hands. The models quickly get a visual understanding of how the hands can enhance the feeling of a photograph.

"Bad" Hands. I am a purist when it comes to shooting hands. When I first started as a fashion photographer, everyone from technicians to editors was aware of "bad" hands. While standards have slipped a bit over the years, most will agree there is something better about a photo where the hands look good. Often, the viewer won't be aware of exactly what makes the difference, but they will say, "I just like this one better!" The difference is hands; bad hands can ruin an otherwise great shot.

General Guidelines. The following are a few of the general guidelines I like to use when posing a model's hands.

A basic rule for hands is to make sure they are never both at the same level in the photograph. The space between the two hands creates an imaginary line. If the hands are at two different levels, this line will be a diagonal one, which is much more interesting than a horizontal line.

In general, you should show the profile of the hand. The palm or back of the hand is actually quite large and will demand too much attention—often drawing the viewer's eye away from the model's face or the product she is selling. Also, age tends to be more visible on the backs of the hands. Additionally, when you are working in a warm environment, the veins in this area may protrude in an unappealing fashion. There are some exceptions, of course. For example, if you were trying to show the emotion of fear, you might want to have the hands wide open and toward the camera in a "Get back!" position.

Keep the fingers together and in a slightly bent position. Spread fingers create too many lines for the viewer's eyes to read. And don't crop or hide those fingers, either. When this happens, the hand looks amputated, leaving the viewer to wonder whether or not the model actually *has* all her fingers.

Keep the wrists either straight or bent slightly. When the wrist is bent, the hand should lift slightly upward toward the shoulder. The hands should never be allowed to flop down; this will make them look lifeless. Also, keep the hands at the same distance from the camera as the body. Extending them out closer to the camera will make them look too large in proportion to the body. Finally, be careful to keep the model's hands away from any problem area of her body. Placing hands there only draws attention to the flaw.

Relaxed Positions. Like the mouth, hands will show tension. I encourage models to relax their hands by shaking them, then letting them fall naturally at the wrists. Most often, the hands will fall into a soft, graceful position that photographs nicely.

Keep the model's hands away from any problem area of her body.

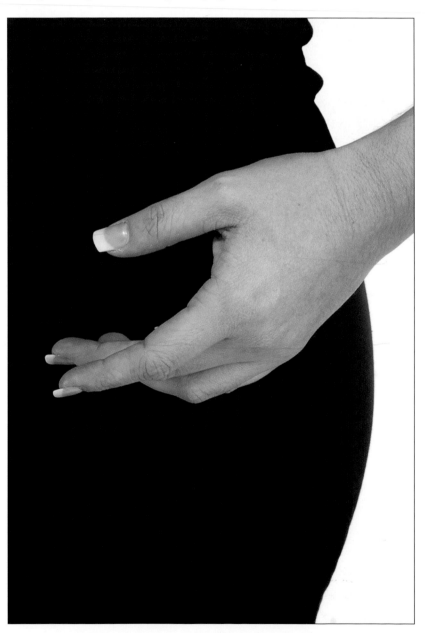

Natural, relaxed hand positions are the most flattering for photography.

This is not how most women hold their purses, but it still looks natural. More importantly, the subject of the photograph (the purse) is completely visible.

When selling products, the hands must work to illustrate the message of the photograph.

Hands with Props and Products. Props and products are two completely different items. A prop is used to accentuate a mood or add to the ambiance of the photo; it is not the focus or the "star" of the shot. Generally, a prop is held more casually than a product.

A product, on the other hand, is normally the focus of the photograph. When selling products (or when demonstrating the model's ability to sell products in images for her portfolio), the hands must work to illustrate the message of the photograph. The hands should draw the viewer's eyes to the commercial product or to a particular feature on a garment (such as a pocket, zipper, lining, button, or the overall cut of the garment). A product must be carefully held so that

The back of the hand is nearly as large as the face. It demands attention, taking the focus from the eyes. This hand position is also quite masculine and unflattering for a female model.

Here the model is putting too much pressure on the hand, pushing the nails into her skin.

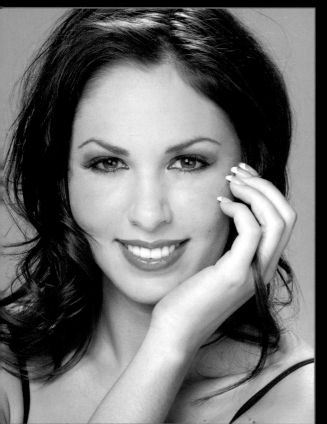

In this photo, the hand frames the face. Note that the fingers rest lightly against the cheek, applying no pressure.

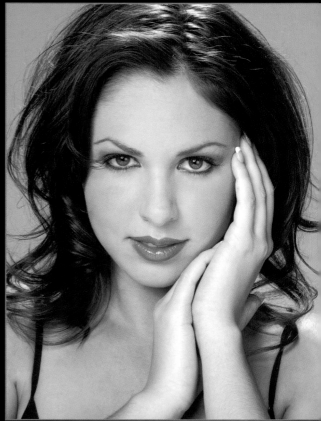

This is the classic "soft hand," a very popular position for jewelry shots. However, it is not necessarily a good position i

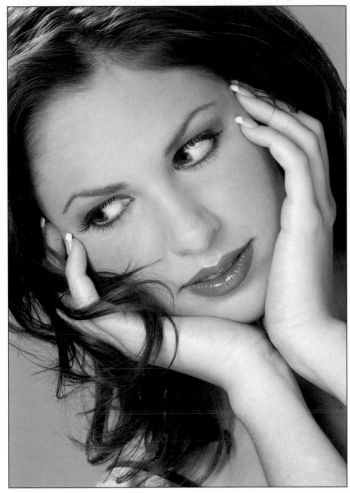 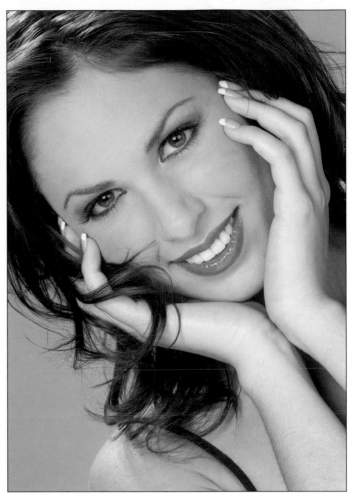

Again, the hands frame the face. In the first image, the model's eyes direct the viewer to the adjoining page. In the second photo, the eyes are directed forward, drawing the viewer into the photograph.

the fingers never cover the logo, name, or other identifying marks. It takes a bit of practice for the model to be able to hold a product in such a way that the client's needs are met and the shot still looks natural and unposed.

Hands Around the Face. When a hand has splayed fingers or is balled in a fist, it tends to look hard and masculine. A more feminine pose has the hand curved gracefully, then gently resting on the body or product. Suppose you want to photograph a model with her hand under her chin. If you allow her to have her fist closed, with the flat of the hand facing the camera, it looks aggressive and hard. Also, the eye is drawn to the center of the fist. If, instead, you turn the hand to a profile position, showing the curve of the little finger, the image will be much more attractive.

Around the face, it is also important that the model not actually rest her face on her hand(s). It is important to avoid pressure that will wrinkle the skin on the face.

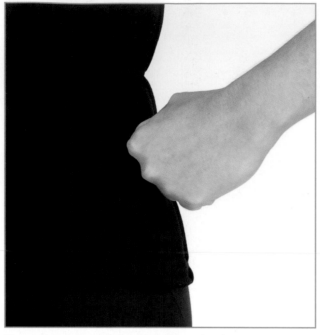

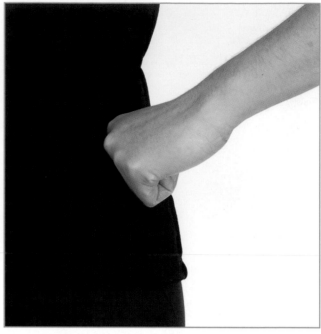

If a model places a fist against her waist, it appears as if her fingers have been amputated.

This is slightly better, because the side of the hand is showing. Still, it's not the best-possible position.

Hands at the Waist. When the hands are at the waist, the general rule is this: hide the thumb, show the fingers. In this pose, the wrists will usually be bent. Make sure that they are not bent out toward the camera. They should be bent down (i.e., the hand should be lifted slightly up toward the shoulders) and/or away from the camera. Watch out for splayed fingers in a pose like this; they can create a significant distraction.

Another pose to watch out for is the "oh my aching back" hand position. The popularity of this pose comes and goes, changing as often as hemlines. However, if photographed from the wrong angle, it ap-

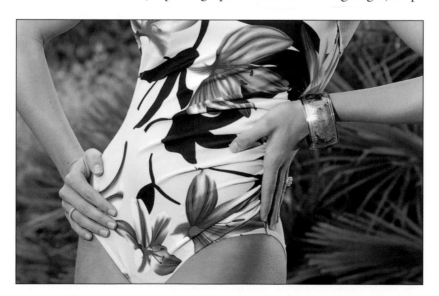

Many refer to this as the "aching back" hand pose. Note that the fingers all show. Many photographers shoot this hand position hiding the fingers, which makes the hand look deformed. To improve this photo, you could slide the hand down and soften it.

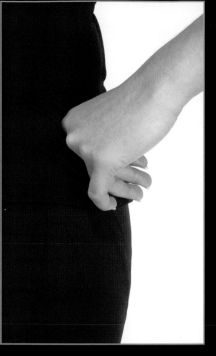
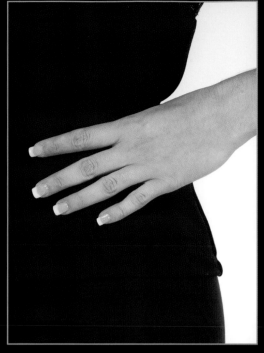
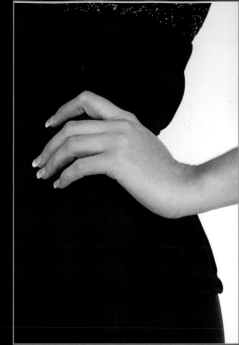

The fingers are showing and a side view is used. Still, it's not the best, because the hand looks distorted.

In this shot, the fingers are splayed straight out, creating a distraction.

Bending the fingers is an improvement, but the pose can still be refined.

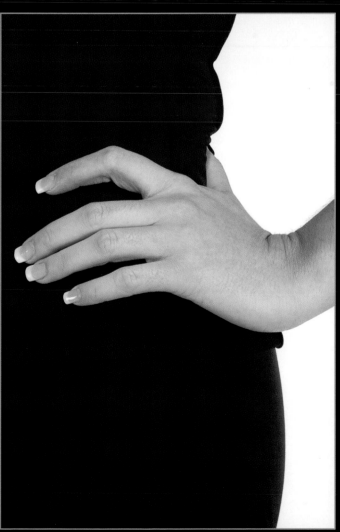
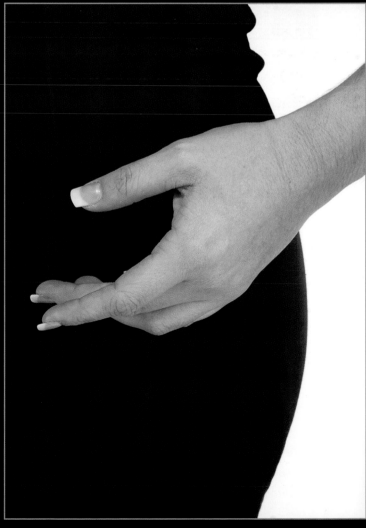

Here's a much better shot. The fingers are all bent slightly, the thumb is barely visible, and the wrist has a nice bend.

Here's another graceful pose with the hand in front of the body rather than resting on it.

pears that a thumb is growing out of the model's waist. If you use this hand position, be sure to photograph it from such an angle that you show the entire hand—with all the fingers!

Hands in the Waistband/Belt. It's common to show a model with one or both of her hands hooked over the waistband of her pants or skirt. The same poses can be used when you want to have the model hook her hand over a belt.

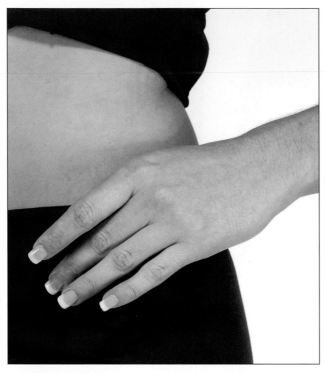

The thumb is hooked into the waistband for a pose that's not too bad.

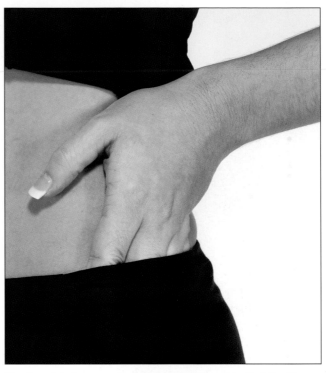

The thumb is too prominent in this pose, and half of the fingers are cut off.

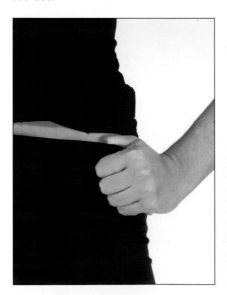

The thumb and the fingers look amputated in this pose.

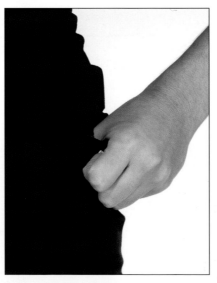

The hand looks like a claw in this bad waistband pose.

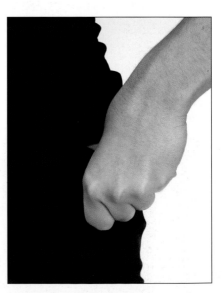

This pose is really terrible—the hand looks totally deformed.

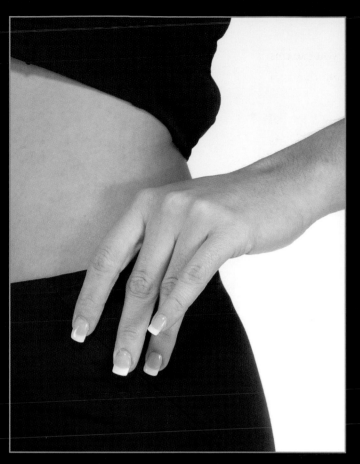

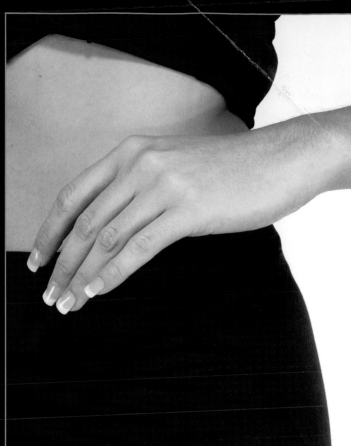

Here are some better examples of posing a hand at the waistband. In these poses, the hand forms a gentle curve that gives it an appealing look.

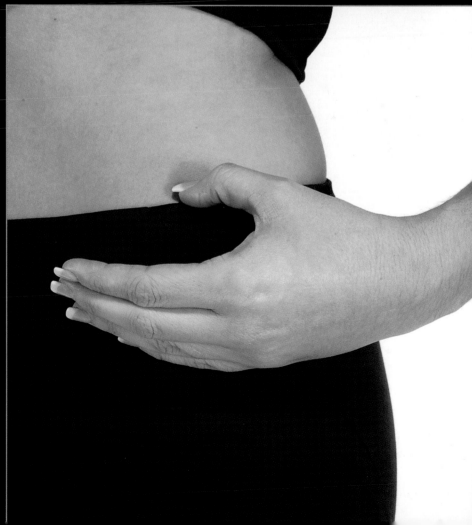

The left and center images show a hand position that is not terrible, but it's also not the best. Depending on the statement required by the pose, it could be a choice to consider. The worst of all cases is shown in the photo on the right. This occurs when a model puts her hands in her pockets and breaks her wrists toward the camera.

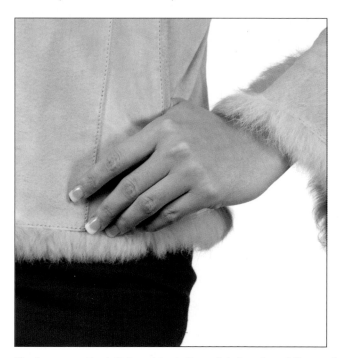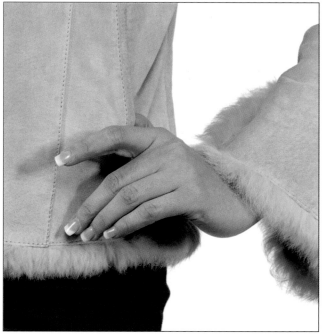

The image on the left is not bad; the wrist, hand, and fingers form a gentle curve. The hand doesn't, however, look as graceful as it could. In the image on the right, a little refinement results in more appealing final pose.

Hands in Pockets. When showing pockets on a garment, the rule is still: hide the thumb, show the fingers. Otherwise, the thumb popping out of the pocket looks quite unattractive. The worst of all cases is when a model puts her hands in her pockets and breaks her wrists toward the camera. Instead, direct the model to put her thumb in her pocket, allow fingers to curl slightly on the outside. This also works well when showing belts.

Hands with Lapels and Zippers. Holding a lapel or the front of a jacket is tricky. Have the model grasp the lapel, thumb up, then turn the wrist slightly and upward so as to show the curve of the little finger. Don't allow the wrist to be too fully bent. Most often, the straighter the wrist, the better.

Here, the thumb protrudes and the fingers are missing.

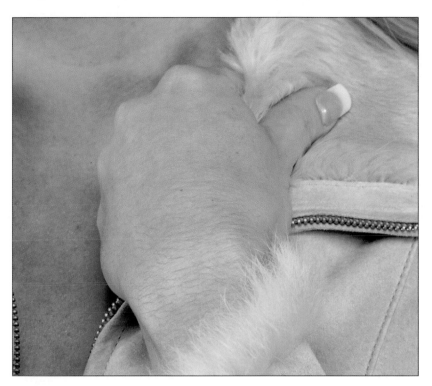

This is a better lapel pose. The hand is shown in a side view, the fingers are nicely curved, and the wrist is gently bent.

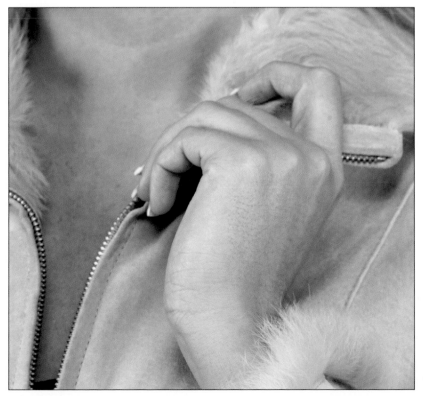

We're so accustomed to grabbing zippers that it's hard to think of having to do it in an "attractive" way. In a photograph, though, what feels natural will rarely look good.

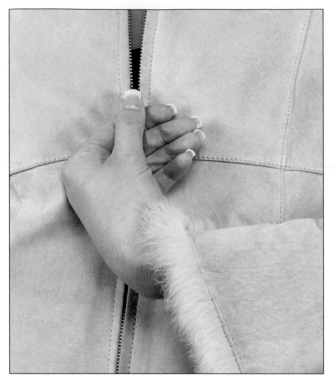 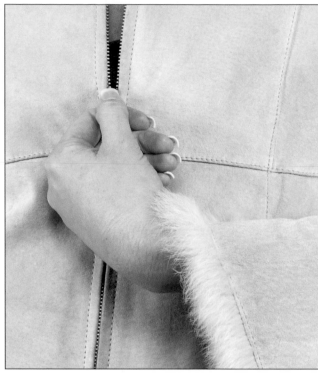

Although this is how many people naturally grab a jacket zipper, the model's hand looks awkwardly twisted.

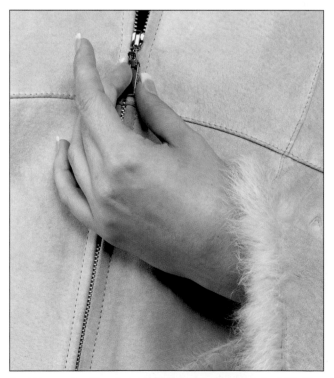 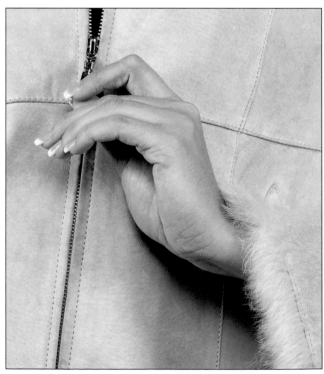

Gently grasping the zipper between the thumb and middle finger creates a better look.

To avoid showing so much of the back of the hand, you could also use a pose like this to show a model unzipping her jacket.

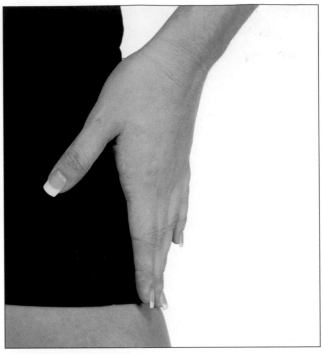

This pose isn't too bad, although it could be a little bit too distracting.

This hand pose is also acceptable, although the fingers may look a little distorted.

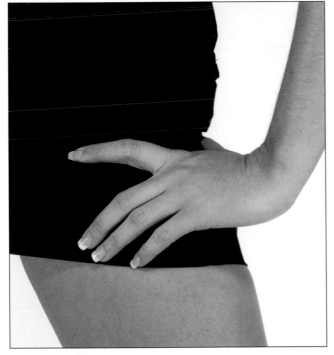

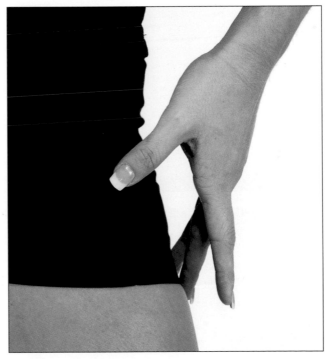

Here's a hand pose that will work if you're trying to create an image with a lot of attitude.

For a graceful look, this hand-on-hip pose is the best one of the series.

Hands on Thighs. If the pose you have in mind calls for the model to have her hand(s) on her hips or thighs, there are a number of nice positions to keep in mind. Which one you pick will depend on the attitude you want to convey in the image.

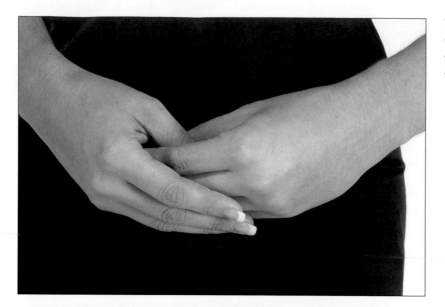

These are classic hand poses for catalog work. They look elegant—and they are subtle enough to enhance the garment, rather than distracting from it.

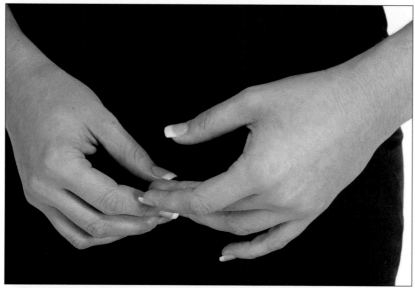

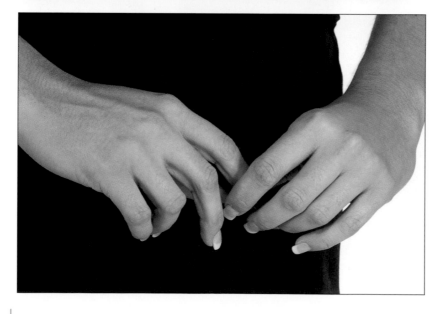

Hands in the Lap. If the photo requires a model to put her hands in her lap area (whether she is seated or standing), one of two ways is acceptable. The first approach is to direct the model to slightly pinch the fingers of one hand with just the middle finger and thumb of the other. Then, have her place her hands in her lap so that they are in profile to the camera. The second approach is to have the model cup her hands, palms up, one inside the other.

In either case, make sure the hands are not too close to the body; this shows tension. For a natural, relaxed look, the hand should be at least a couple of inches from the model's torso. Often, I will also have the model place her hands to one side or the other, rather than right in the middle of her lap.

When posed correctly, the hands should be undistorted, looking relaxed and natural.

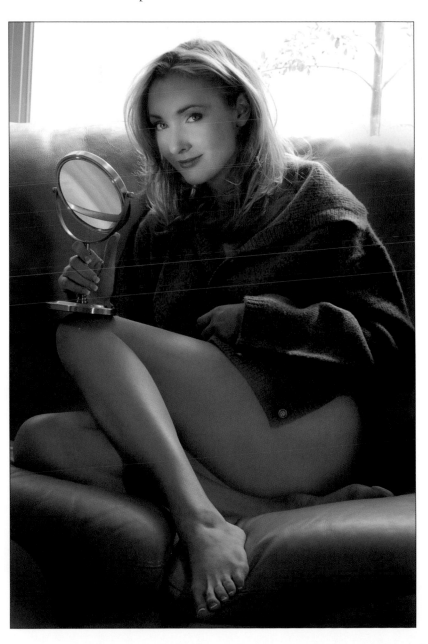

Practical Examples. Here are some additional images for you to study when thinking about hand posing. The model for these shots was Mary. As you can see, she's able to create a wide variety of poses using simple variations.

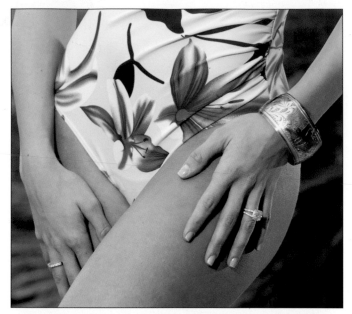

LEFT—This is a nice hand pose, except that the fingers are spread a little too far apart. When shooting for a commercial client, be sure the model doesn't wear jewelry that may detract from the client's product.

BOTTOM, LEFT—Notice how small modifications can change the photo from a catalog-style image to a more sexy, glamour-style photo. The model has the same basic body position, but as soon as she looks into the camera, her eyes become the center of focus.

BOTTOM, RIGHT—As the body is turned to create more of a figure/glamour shot, the image loses its catalog value. Note how the drop of the shoulder strap adds a seductive look to the shot.

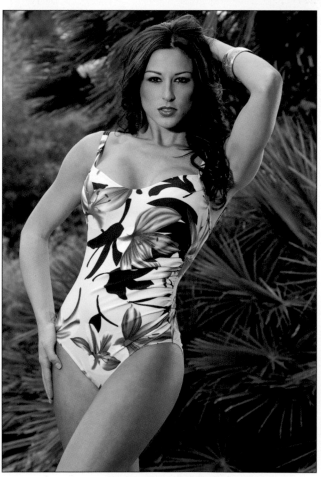

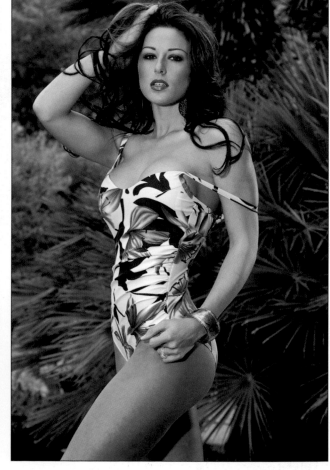

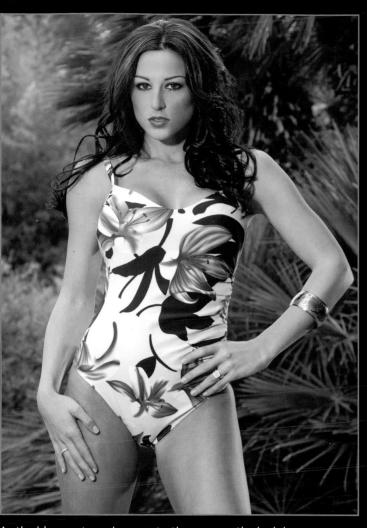

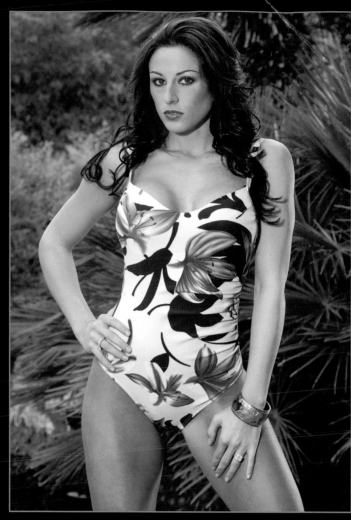

As the hips are turned square to the camera, the look becomes more assertive—like what you would see in traditional poster photography. Watch the placement of the hands so they don't lead the viewer's eyes to the groin area.

RIGHT—To create a nice pose that shows the back of the swimwear, direct the model to lift her arms and glance over her shoulder. She can also rotate her chest a little toward the camera. If the model looks directly at the camera, it will divert some attention from her rear end.

FAR RIGHT—A tight crop of this position can also be a very pleasing headshot if the model leans toward her shoulder.

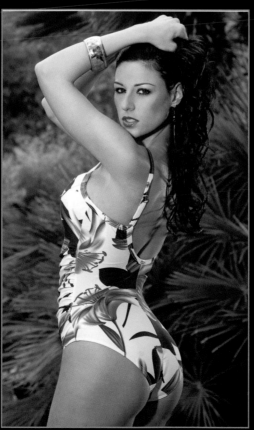

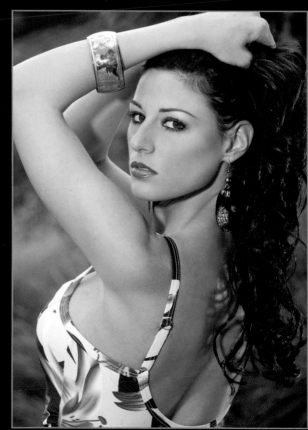

In this next series of images, created with Marisa, you see an example of selective coloring. This technique was used to draw your attention to the swimwear by reducing the coloration in the background. Again, you can see the variety of poses created.

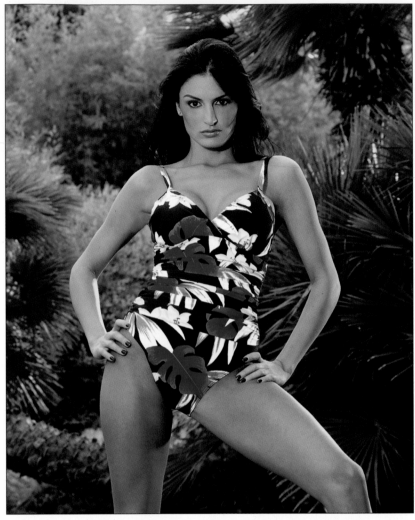

LEFT—This is a flattering photograph with solid posing.

BOTTOM LEFT—Here we see a bad hand pose; the fingers are splayed and the flat of the hand is directly toward the camera.

BOTTOM CENTER—When one or both wrists are broken toward the camera, it creates a very ugly and awkward hand shot.

BOTTOM RIGHT—This is an example of the "oh my aching back" hand pose. If this position is used, it must be shot so that the entire hand shows. Otherwise, you will see the distortion shown here.

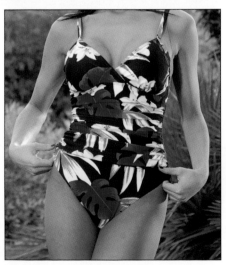

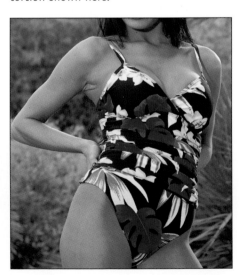

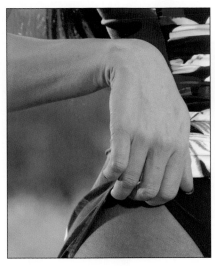

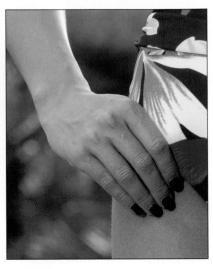

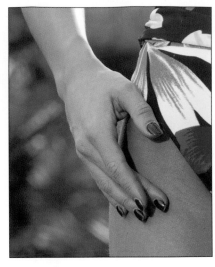

Again, the wrist is broken toward the camera, creating an ugly hand position.

Note the straight wrist, slightly broken away from the camera. This is a much better position.

I like this hand position. It is in a partial profile that gives a thinner, longer look, and the fingers are graceful.

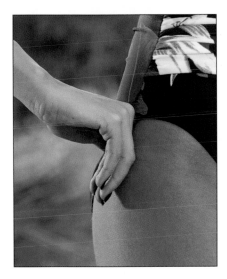

ABOVE—This is a graceful way of placing the knuckles against the hip. Too many photographers allow the model to make a fist when placing the knuckles in this manner. The result is fingers that look amputated.

RIGHT—As the model places her hands behind her head, it stretches the swimsuit and lengthens her body. But be careful when the legs are in the crossover position, as here; they can visually merge and look like one big mass.

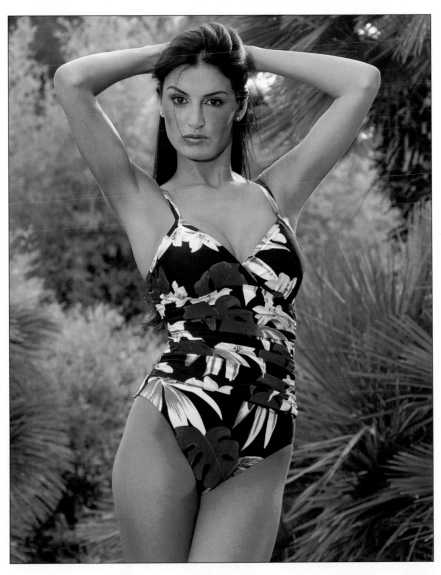

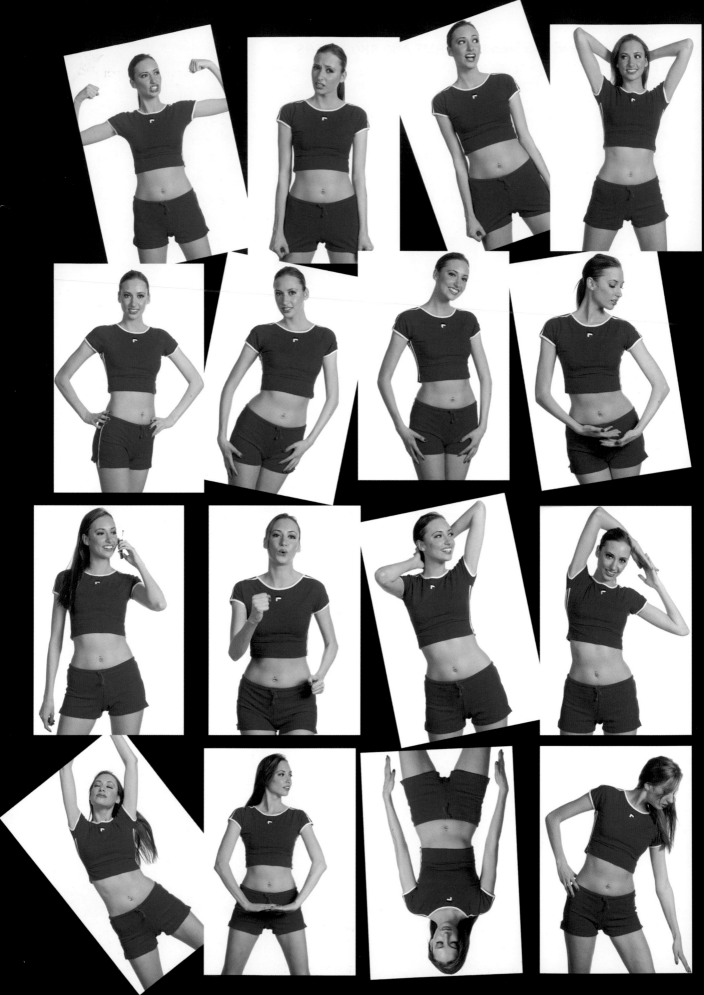

FACING PAGE—For her agent, Iana needed a promo page that showed the many personalities she is capable of depicting. Note the variety of arm poses and expressions she used to communicate this ability. (And, yes, we intentionally placed one of the photos upside down to draw attention to the variety in this promo piece.)

Here, a low camera angle and wide-angle lens were combined with a dramatic pose to produce a dynamic photo. However, the model's arm is hyperextended—it almost looks broken. Fortunately, this is just an outtake from a session with many other perfectly posed shots.

ARMS AND SHOULDERS

Separation from the Body. Make sure the arms are never posed in contact with the side of the body. Holding the arms away makes the waist look slimmer and avoids the appearance of a solid body block. This creates a much more feminine and pleasing line.

Elbows. Be careful never to allow the model to lock her joints. This distorts the arm and creates a very ugly line. You should also avoid any pose that places the point of the elbows directly toward the camera. I once saw a photo where the model had clasped her hands behind her head with her elbows facing the camera. It looked like she had two large appendages growing out of her neck!

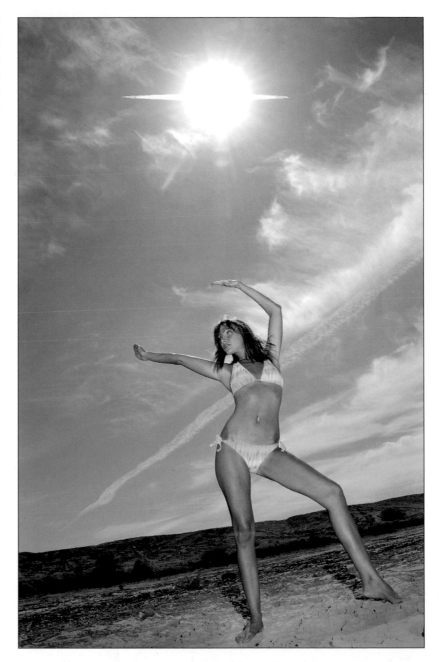

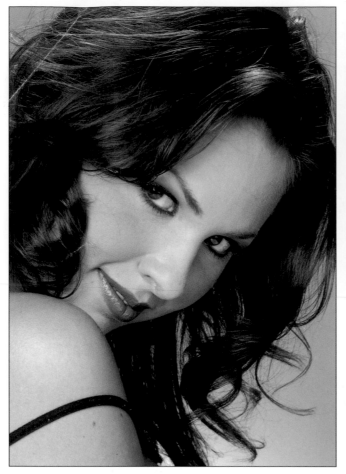

In this photo, the shoulder is cutting off the view of the model's face. Cropping tighter and moving in so that the focus is on the eyes could easily improve this photo.

When the arms are posed to frame the face, long sleeves can be used to prevent them from distracting from the intended subject of the image.

Framing the Face. The arms can be used to frame the head, drawing all attention to the face—and specifically the eyes. When leaning forward with the arms up to the face, direct the model to put her weight on her elbows and avoid clenching her biceps to her forearms. This will cause the flesh to mushroom out, making her arms look larger than they really are. You should also avoid poses where the arms or shoulders block your view of the model's face.

Arms Raised. Whenever the arms are raised behind the head or up to the face, try to cover them with the model's long hair. This breaks up the flat planes of the arms. If left uncovered, the bare arms will record as lighter than the face (which has makeup on it). This produces a distraction and looks unnatural.

3. Posing the Head and Face

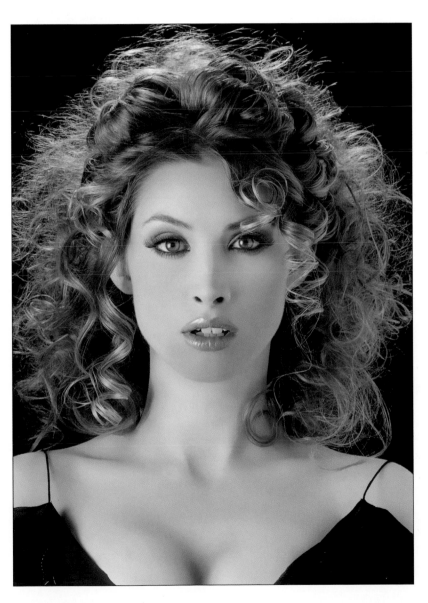

VIEWS OF THE FACE

When photographing the human face, there are three principle views that you can produce.

Full Face. The first is a full-face view. This is produced when the model is facing directly into the camera. In this pose, both ears are visible. A full-face pose is good when you want to show the symmetry of a model's face, or when you want to convey an assertive attitude.

Three-Quarter View. When the model's face is turned slightly away from the camera, the far ear disappears. This is a three-quarter view of the face. This pose is good for revealing the shape and contours of the face. It is also more demure and less assertive than a full-face view. Normally, it is recommended that the face not be turned so far that the nose extends past the line of the cheek.

In a full-face view, you see both of the subject's ears. This view works well for a shot where you want to show symmetry.

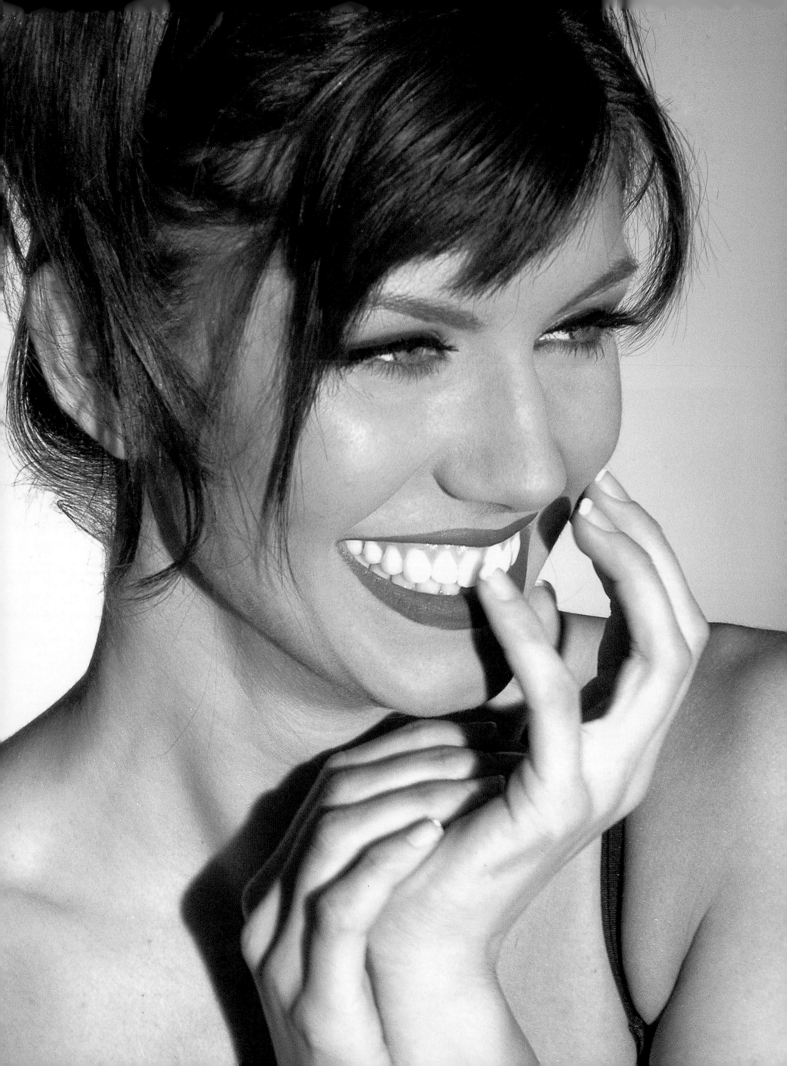

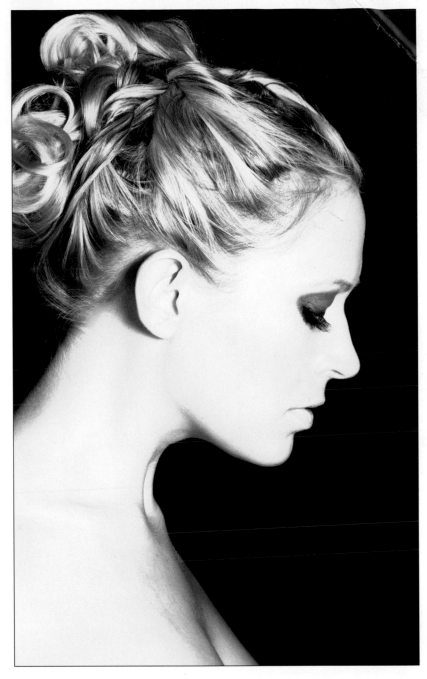

This is a classic type of portrait that exudes grace and abiding beauty.

Profile. When the face is turned at a 90-degree angle to the camera, the pose is called a profile. In this pose, only one side of the face is visible. This is a classic type of portrait that exudes grace and abiding beauty.

TILT OF THE HEAD

In addition to the horizontal angle of the face to the camera, you can also finesse the vertical position to get just the look you want. As noted previously, vertical lines create a solid, forceful look in an image. This is the effect you will suggest when the model's face is posed vertically.

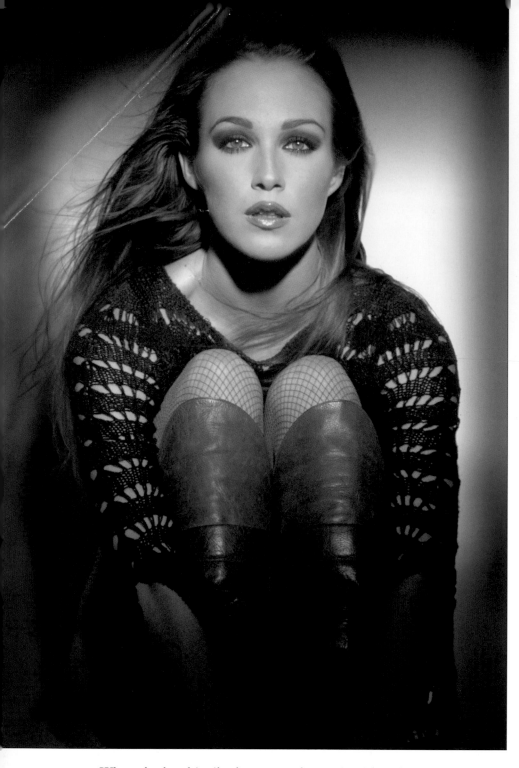

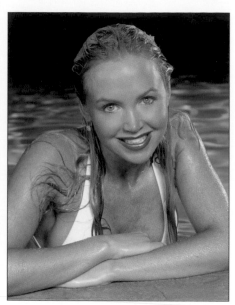

LEFT—Posed vertically and in a full-face view, the face has an assertive attitude.

ABOVE—While still in a full-face view, tilting the model's head softens the look.

When the head is tilted to some degree in either direction, the look will be softened by rendering the face as a diagonal line.

EYES

It is said that the eyes are the windows to the soul. In photography, the eyes are possibly the most vital element of the image. They create a sense of communication with the viewer, they can show mood, reveal character, or create tension. They literally create the flow of the photograph. Eyes can give a photograph a sense of power, depth, and

intimacy. If used incorrectly, however, the eyes can also ruin an otherwise great photo.

In commercial shots, the model generally will look away from the camera, since the product takes first billing. For portfolio development, however, the opposite is true. The model is the product and, therefore, the eyes should be looking at the camera, and the photographer should always focus on the model's eyes. This is what draws the viewer to the image and forms a connection between the model and the possible client. This connection is vital and can make the difference between success and failure. To establish a connection, I remind the model to focus on the lens and "flirt" with the camera. I ask the model to imagine she is placing her face on the film (or, today, the digital image sensor!), and look through the lens to the film.

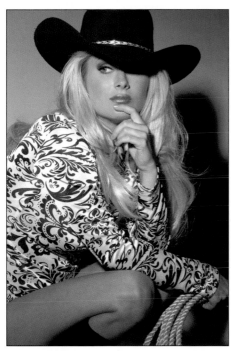

ABOVE—In a commercial image, the model usually looks off camera. This allows the viewer to connect with the product the model is selling rather than the model herself.

RIGHT—In a portfolio image, the model herself is the product. Direct eye contact will help her make a connection with the viewers of the portfolio—her prospective employers.

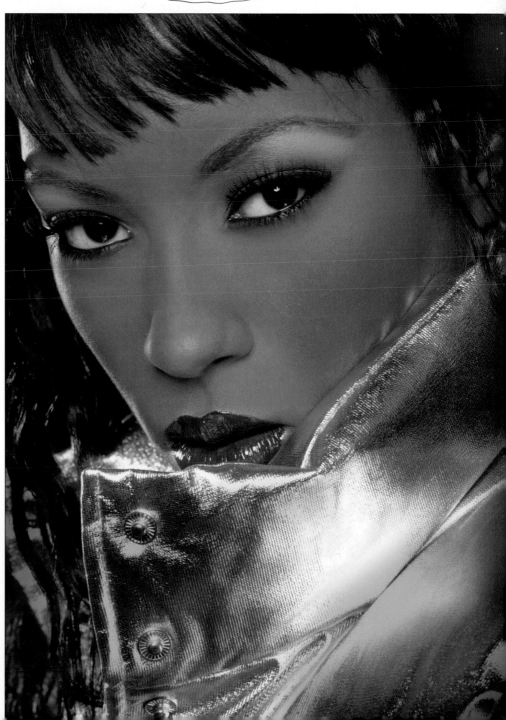

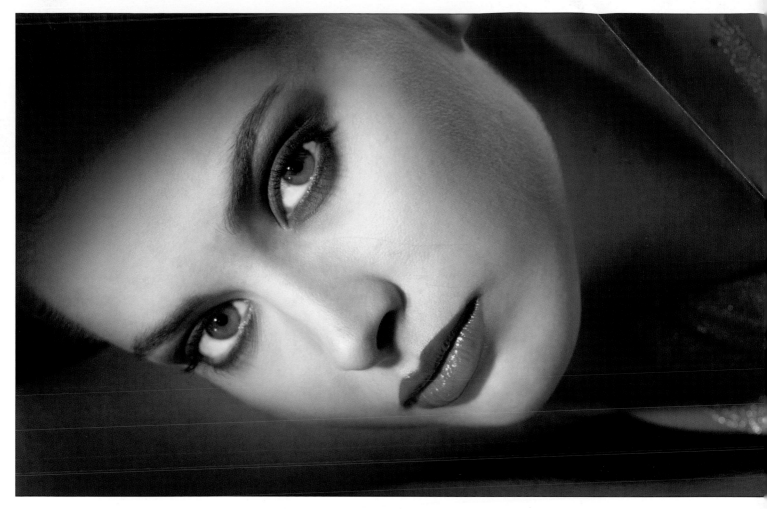

ABOVE—If the eyes are the most important feature of the photograph, position the model in such a way as to truly emphasize their beauty.

FACING PAGE—Closing the eyes makes nearly as much impact as having the model look directly into the camera. When shooting for a makeup artist, using a closed-eye shot is mandatory.

Inexperienced models often stare at the camera in a "deer in the headlights" manner. To avoid this, I suggest the model periodically look away, then return her focus to the camera in order to maintain a fresh, spontaneous look. If the head is at an angle I don't want to lose, I'll instruct the model to simply lower her eyes, then slowly raise them to the camera. Beginning models also tend to look to the photographer or stylist rather than connecting with the camera lens. It is necessary to remind them that they need to connect with the person viewing the photograph down the road, not those in attendance at the shoot.

Another technique that works well is humor. I gently tease the model about silly topics—just to break the tension and keep the shoot flowing in a lighthearted manner. Some of the most spontaneous expressions I've ever captured have been the result of some goofy comment. Be careful, though; this only works if the photographer has developed a comfortable, communicative relationship with the model.

A talented makeup artist can be a photographer's best friend. Eye enhancements are limited only by the artist's imagination, and may

SHOWBIZ

good vs evil
nightly

include sunglasses, contacts, eyeshadow and eyeliner, sequins, lace, feathers—the possibilities are endless. Most commercial shoots involve the use of false eyelashes to enhance the model's eyes.

LIPS

Lips are second in importance only to the eyes. For better lips, don't use only one lip color. This creates a cartoon-like, flat look. A good

The eyes can be used to force the viewer to look at certain areas of the page. Notice how the direction of the model's gaze in this image draws your eyes to the white text at the top right of the page.

makeup artist will start by applying one neutral color over the whole lip. Then, she will add a darker color from about a quarter of the way out from the middle of the lip to the corner. The look is then completed with the addition of a lighter, reflective color on the middle of the lip. By using multiple colors, one can get beautiful shaping, as well as moist-looking and more appealing lips.

A slight separation of the lips will give the model a pleasant, unforced expression and will soften the jawline. Tell the model to open her lips just enough to feel the air break over her bottom lip.

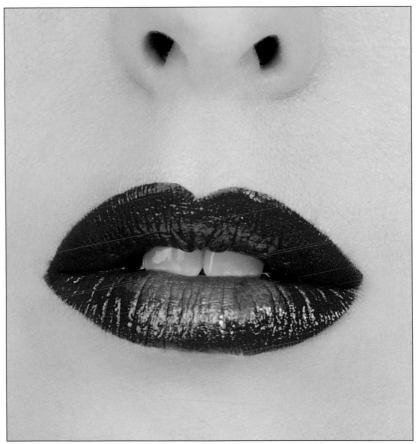

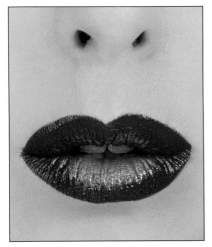
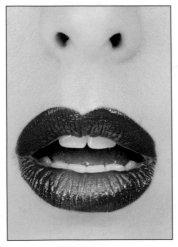
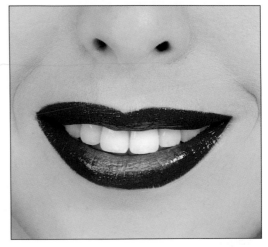

Having the model silently say certain words and watch her lips go through many attractive positions. Have her re-create some of these positions. Be prepared! Models will usually laugh or giggle when they say a word like "hot." You can get a great, natural-looking shot if you are ready.

Merry Christmas!!!

$ 5.00
USA

$ 5.00
SA

$ 5.00
USA

Postal Service

Your package is in
the mail.

Postal Service

892177 033844

2007

LEFT—Directing the model to open her mouth until she can just feel the air across her lips will make the lips look larger.

FACING PAGE—Here, the mood is playful. The use of a candy cane helped the model pose her lips perfectly for the shot.

When training a beginning model, have them use their hands to cover everything except their lips, then give them words to demonstrate, using only their lips—happiness, anger, pride, softness, etc. This way they see the importance and use of lips to create the intended mood.

Direct the model to open her mouth so that she can just slightly feel the air across her lips. This will make the lips appear larger. It will also relax the jaw, since she cannot clench her jaw with her lips slightly open.

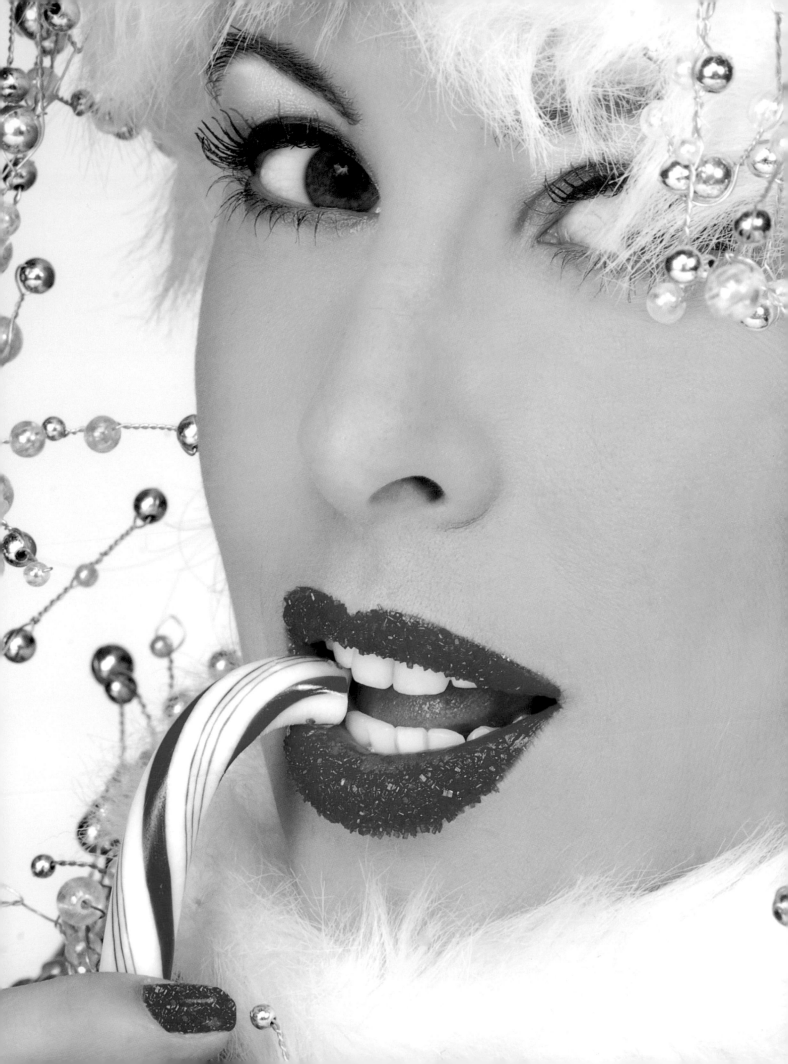

EXPRESSION

Expressions must be spontaneous, even though they are planned to obtain the desired result. An experienced model can counterfeit a genuine emotion, but often the photographer must assist her to make it happen. This is accomplished by creating a situation or an atmosphere that will evoke a "natural" expression.

When a model is struggling with expression, direct her to use words to both help create expression and draw her concentration away from her struggle. I often use "hot." This has a two-fold benefit. First, in saying the word, the mouth will take four shapes. If the photographer is quick, at least one of these will photograph well. Also, this word tends to make the model giggle, further relaxing her. Another word I have used is "true." This creates a bit of a pout.

Sometimes a model gets really nervous and her upper lip may stiffen and quiver. When this happens, I will ask the model to say, "alfalfa." The first two syllables will relax the mouth, and the "-fa" syllable produces a nice shape for the mouth.

The list to the right details just of few of the many facial expressions you can work on creating with your models.

POSSIBLE EXPRESSIONS		
Charming	Curious	Angry
Laughing	Confident	Coy
Sleepy	Happy	Devilish
Serene	Excited	Sarcastic
Sensual	Surprised	Calm
Amused	Flushed	Cheerful
Shy	Playful	Alluring

Being able to produce a wide variety of spontaneous-looking facial expressions is a great skill for models to develop.

4. Posing for Different Genres

The age of the model is one determining factor in the type of work she is best suited for.

DETERMINING THE BEST MARKET

When working on a model's portfolio, there are three major criteria you need to keep in mind: age, height, and overall appearance. These will help you to determine the markets in which she is most likely to obtain work and, therefore, the types of images (and poses) you should use in her portfolio.

Age. The model's age will help you to determine whether her portfolio should be directed toward a local, regional, or international market. Generally, models under sixteen are limited to local and regional modeling because of school requirements, work restrictions, the need for chaperones, etc. While it is true that international agents accept younger models, especially in Japan, this is the exception rather than the rule.

Models who are over twenty-one also tend to be limited to local and regional work. This is because most major high-fashion agencies are hesitant to invest their time, effort, and money in a model who has a "limited shelf life." This is harsh but true. Of course, there are commercial and talent-oriented markets in which over-twenty-one models are considered very desirable. (*Note:* A "talent" is someone who specializes in acting roles, such as in television commercials or as a spokesmodel for a particular company.) Be prepared to offer these market possibilities as an alternative for the prospective model who happens to be a bit older.

Height. Height is critical. Shorter models are limited to more commercially oriented work and specialty modeling, such as hand work, fit (a model that designers hire to fit clothing on during the design process), lingerie, swimwear, hair, and beauty (modeling where the products [such as makeup, jewelry, or hair care products] require facial beauty). Taller models have a much broader market.

Overall Appearance. Here your own personal "eye" will determine whether or not it is worthwhile to work with the potential model. Styles and preferred looks change as often as hemlines. What was unacceptable two years ago is in demand now. It is the photographer's responsibility to stay informed of the current "looks." However, clean skin, straight teeth, and good bone structure are always in fashion.

Once you have determined the market in which your client wants to seek work, you can begin thinking about how to create images that will help her reach that goal. Keep in mind that these are only

Tailoring a model's portfolio images to the market for which she is best suited will enhance her chance of finding employment.

The height of the model will also determine the type of work she is best suited to.

guidelines—generally accepted standards. If a model doesn't fit in the category she wants to work in, a great portfolio and a lot of determination can still help to make it happen.

As you read through the details that follow on the different sub-genres of model photography, examine the images carefully. Think back to the posing techniques we have looked at in the previous chapters and consider how these different strategies are used to create a pose that is harmonious with the intent of the image. In particular, study the lines created by the model's body, the expression on her face, and how all the elements function in terms of composition (*i.e.,* how your eye flows through the frame and where it comes to rest).

COMMERCIAL

Commercial print work refers to photographs used in magazines, newspapers, catalogs, point-of-purchase packaging and displays, billboards, etc. Ad agencies or manufacturers who are trying to sell a specific product or service create this market. This is a lucrative area of work because of the high-profile usage of the image and the availability of exclusive contracts. These ads can define a product's reputation,

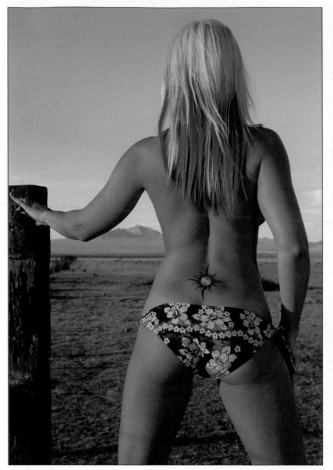

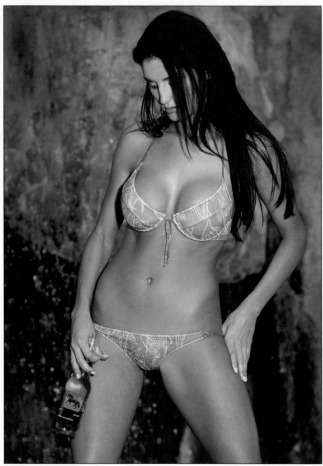

ABOVE—In commercial print work, the model is used to draw your attention to the product—whether it's bottled water or bikini bottoms.

LEFT—When working for a client, the art director or ad agency will usually present the photographer with a storyboard or layout of the photos needed.

so the work is also demanding. Everything must work together—the model, the photographer, the stylist, the advertising director, and the garments/product—if the desired image is to be realized.

Because commercial print work is very product oriented, it generally requires a different type of model than normally used for fashion-oriented ads. For example, commercial print images may feature

anyone from a little baby crawling on the floor for a diaper ad, to a gray-haired, little old lady advertising an assisted-living home. Commercial print work may also include using body-part models, such as those who specialize in hand modeling.

In commercial print work, remember that neither the backgrounds, the models, nor any other objects can obscure or overpower the product. In commercial print, the product is the star and the viewer's eye must be directed to it. When working for a client, the art director or ad agency will usually present the photographer with a storyboard or layout of the photos needed. Rarely does the photographer have the freedom to create his own shot, but rather is responsible to re-create the layout as presented. Therefore, his main responsibility is to set the lighting and create the mood directed by the art director.

When shooting commercial print work, the model is not the focus of the shot. Instead, the product is the star.

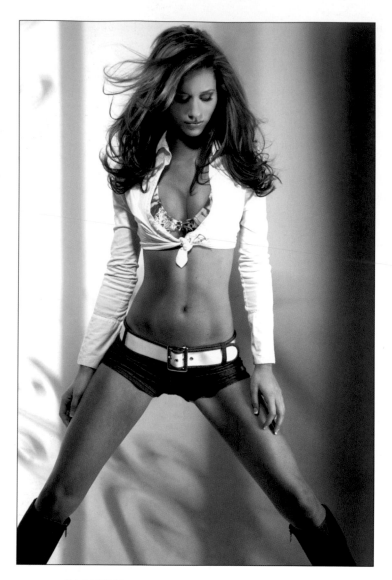

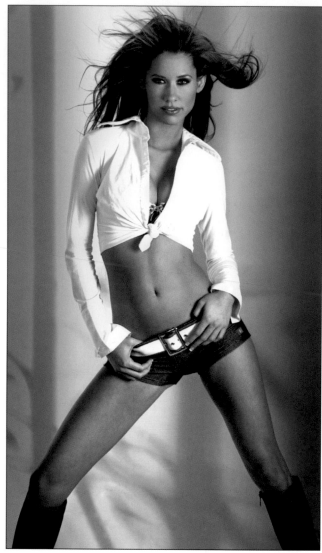

FASHION

The fashion photography genre includes images of anything that can be worn—garments, hair-care products, perfumes, makeup, jewelry, etc. There are several types of fashion print work, including editorial, catalog, athletic/sports, swimwear, and lingerie. Fashion print generally utilizes the typical fashion model—a tall, thin, beautiful person. However, there is a trend toward using "real" people, including plus-size models (see pages 90–93), in mainstream fashion print.

GLAMOUR

To the general public, the term "glamour photography" brings to mind classic photos of Marilyn Monroe, Elizabeth Taylor, or the current crop of Hollywood superstars. For the commercial photographer, however, the term is used to describe any work that emphasizes the beauty of the human body. While it can include nude photography, it

ABOVE—Fashion images typically feature tall, thin, beautiful models.

FACING PAGE—Fashion print work includes images that promote cosmetics as well as clothing.

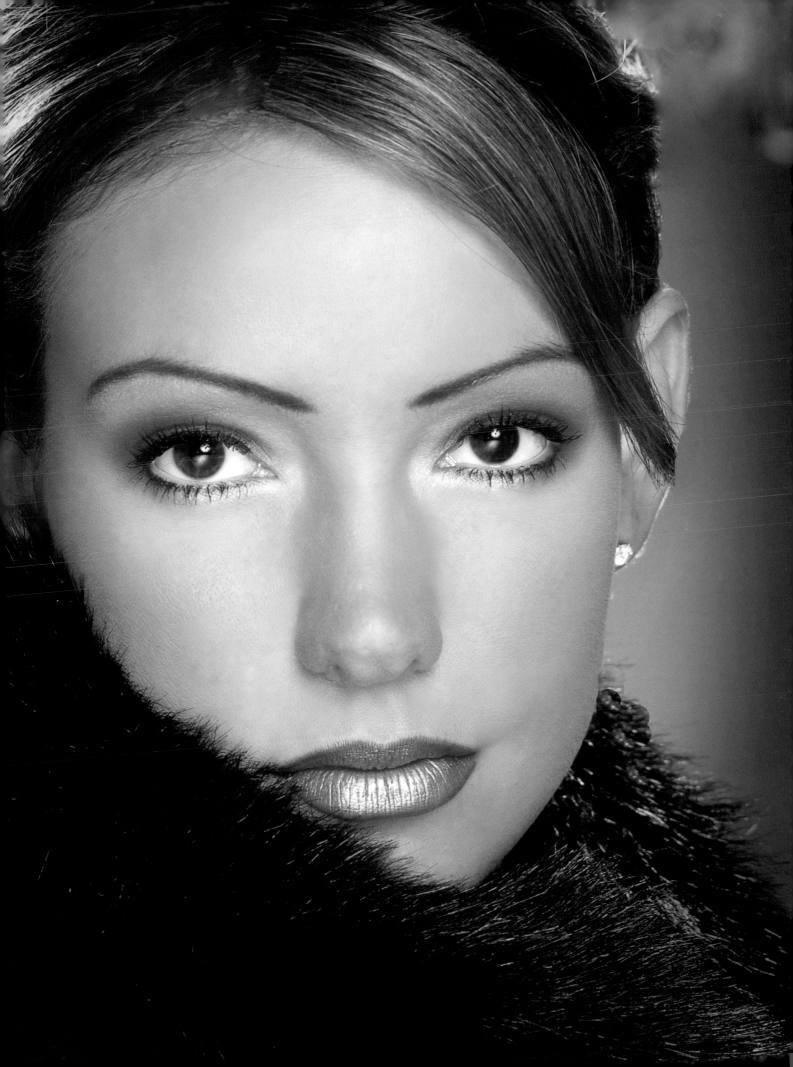

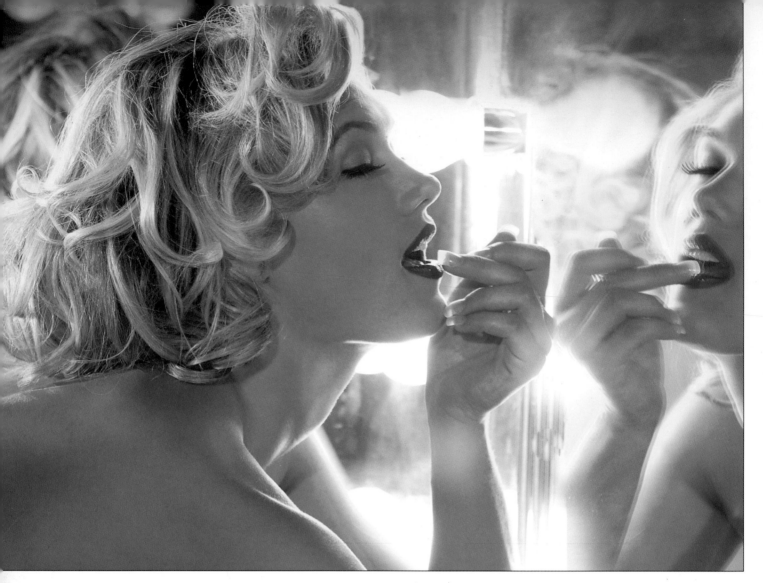

is not limited to nudes; it may also include the use of lingerie, swim-wear, and other clothing.

Some glamour shots may be useful in the beauty industry for the promotion of commercial products. Another opportunity for the publication of glamour photography is in the finer adult magazines; on selected web sites; and for calendars, posters, and other retail products.

Tasteful nudity has become acceptable, as long as it is subtle and sexy, rather than tacky or risque. As a result, the typical subject used in glamour photography has shifted from the busty, blatantly sexy, bottle-blond to the beautiful, perfectly proportioned woman with a sexy, girl-next-door look. Proof of this is the fact that the more sophisticated men's magazines have become very celebrity driven, featuring tastefully glamorous images of many of today's supermodels and Hollywood stars. (*Note:* Again, the keyword here is "tasteful." The more hardcore men's publications are called "top-shelf" magazines, and most commercial clients will not touch a model who has done top-shelf work.)

ABOVE—This image was created in a classic glamour style, reflecting the early Hollywood roots of the genre.

FACING PAGE—Glamour photography is the term used to describe tasteful depictions of the beauty of the human body.

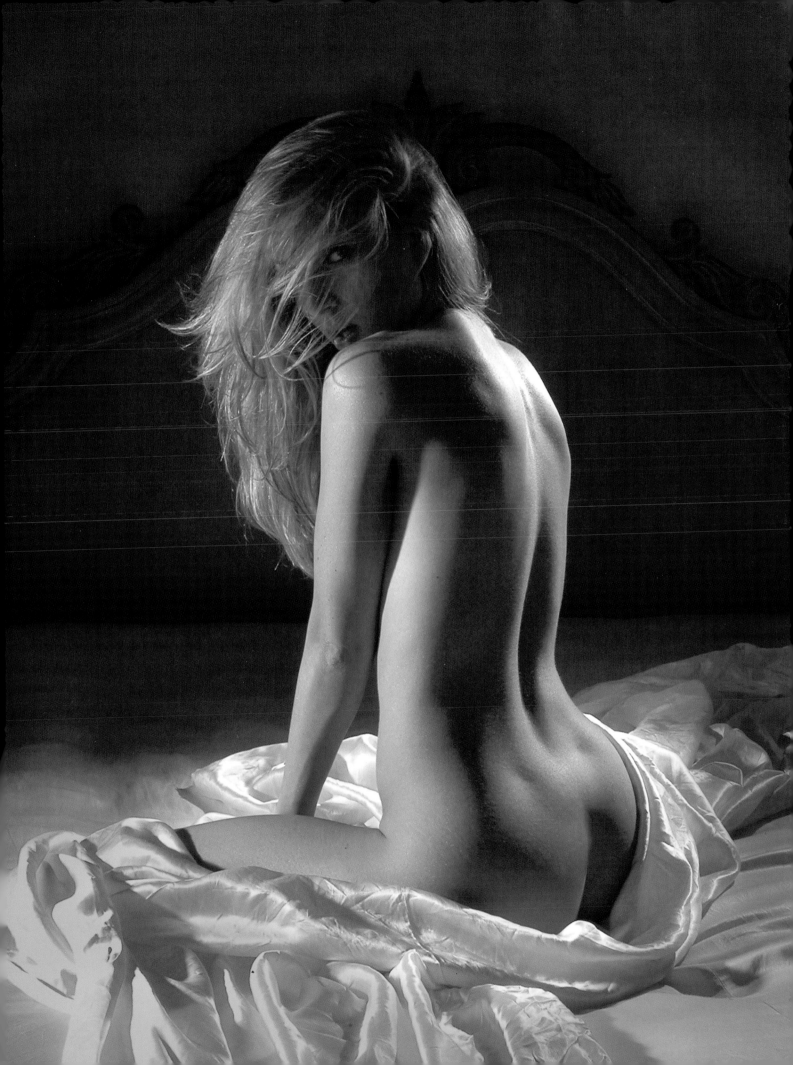

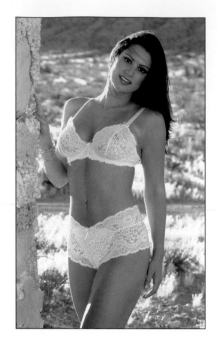

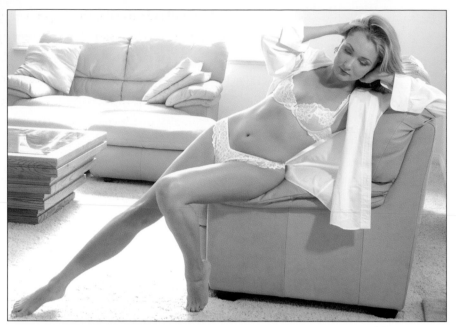

Some clients want more of a catalog-type look for their lingerie images (left). Other want to create more of a mood in their advertisements (right).

LINGERIE

Lingerie photos can be created either in the studio or on location but should, of course, be shot with good taste and sensibility. Commercial lingerie photography must be exquisite and beautiful but not sexual. If the shot becomes sexual, you are no longer selling the lingerie—you have crossed over into glamour and are showcasing the beauty of the model.

The advertisers will determine the focus of the shoot. Sometimes, they want each photo to detail a particular garment. For example, a client may request that the photograph concentrate on the strap of a bra, the underwire, or an especially beautiful strip of lace. Sometimes, they simply want to invoke a feeling of romance, excitement, or glamour. Some clients request more catalog-type photos; some allow the photographer more of an outlet for his personal creativity.

As with swimwear models (see page 97), models for lingerie shoots are generally shorter with more curves than the typical high-fashion model.

> Sometimes, they simply want to invoke a feeling of romance . . .

PLUS-SIZE MODELS

In the fashion business, a model who wears size 10, 12, 14, and up is termed a plus-size model. The highest-paid plus-size models are normally sizes 12, 14, or 16. When working with plus-size models, there are two ways to approach the session.

The first approach is to use every technique in the book to visually slim the model. This could include exaggerated posing, specialized lighting, and the use of image-editing software in postproduction. If

you decide to take this approach, you can visually extend the model's legs by having her wear extremely high-heeled shoes. She can even wear multiple bras to reduce her bust size, or throw her hips dramatically off angle to slim this area. Leaving much of the body in shadow or reducing the separation between the subject and the background can also produce a slimming effect.

These exaggerated techniques are normally used only when photographing portfolio images for a model who is concerned about her

Plus-size models are finding more and more work today, as clients and advertising agencies expand the use of "real people" in their images.

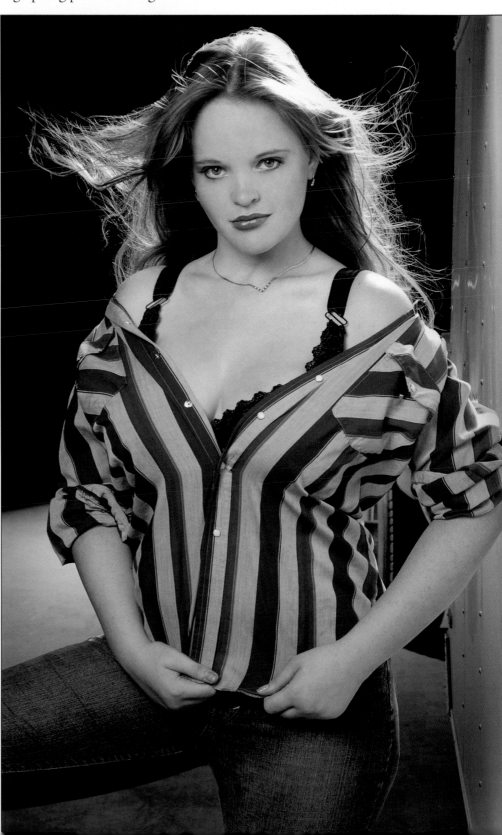

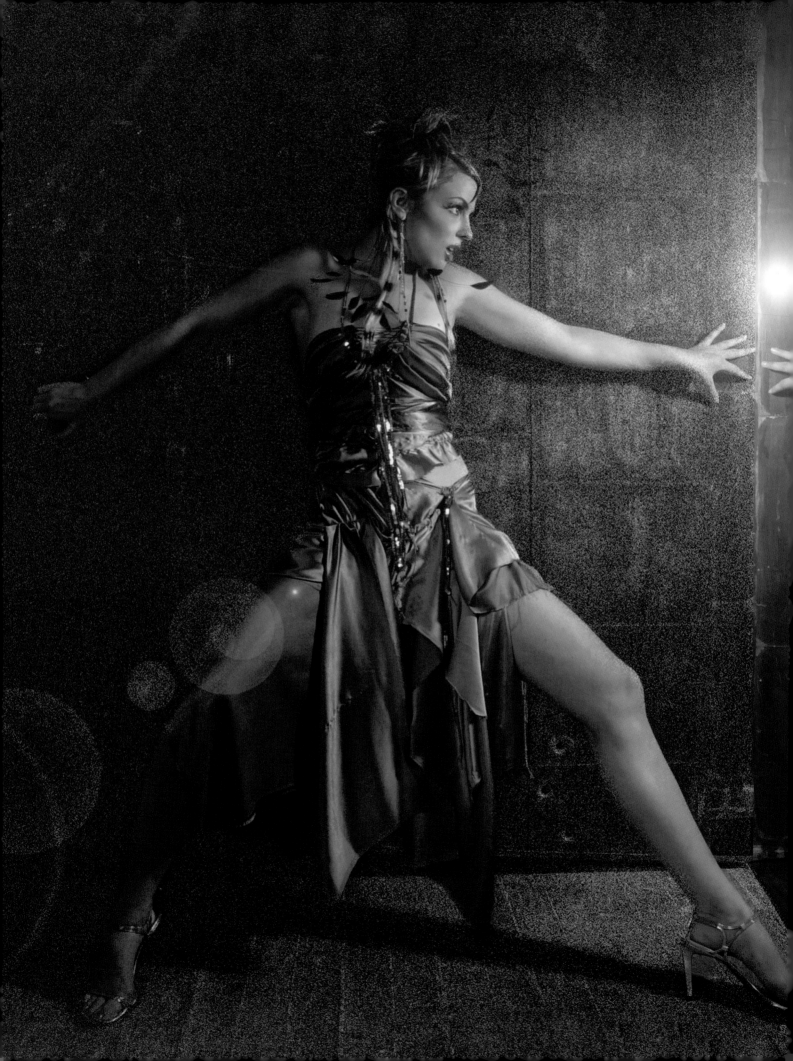

appearance, or when a client books a particular model because they something special in her but still want to reduce her size visually.

The second approach is used when a plus-size model is booked by the client as a plus-size model—perhaps to advertise plus-size clothing or to appeal to customers with more average builds than the typical fashion model. In this case, the model should be photographed using the same methods as you would use with any other model. No special techniques, posing or otherwise, are necessary. Today, clients and advertising agencies are expanding the use of "real people" in their advertisements, so this is often the scenario you encounter.

EDITORIAL

Editorial work is the part of the magazine created by editors, not advertisers. These pages promote a general trend or idea rather than a specific product. When creating this type of work, the editors and photographers are responsible to the style and outlook of the magazine rather than to the manufacturer of a garment or product. They try to create a look that will become the next trend.

This is the most prestigious and glamorous work for a fashion photographer—but not the most lucrative. This is because editorial work is wonderful for building a photographer's reputation and for gathering those all-important tear sheets. Since magazines know that editorial tear sheets are career builders, they pay less money.

Agencies are expanding the use of "real people" in their advertisements.

BELOW AND FACING PAGE—The poses and models used in editorial images can be extremely varied. It all depends on the trends the magazine wants to showcase or explore.

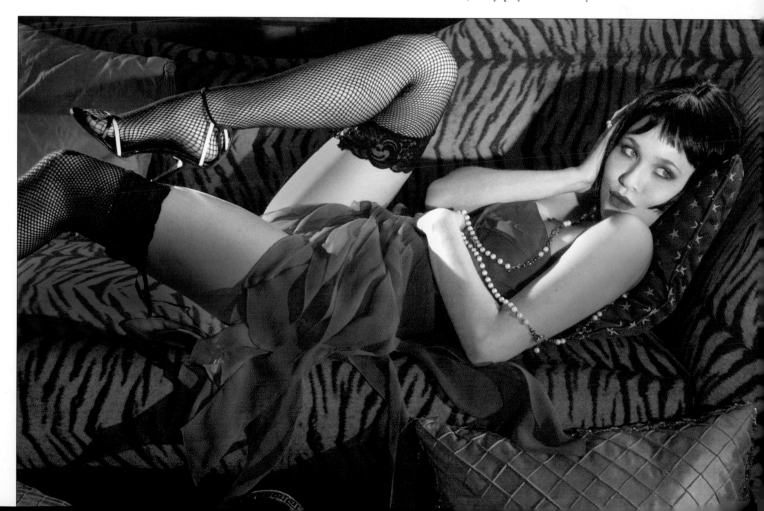

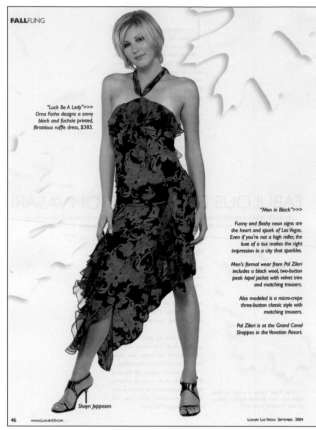

The big benefit of shooting for the editorial pages is that it offers greater artistic freedom. These images don't require as much constraint as advertising work for specific clients, so the editors are free to experiment with new faces, new ideas, and sometimes even new photographers. The most slick and prestigious magazines, however, tend to stay with established photographers for their editorial pages—artists who have proven themselves able to create dramatic, edgy photos.

Editorial images can be career builders. As a result, they typically pay less than advertising work.

ATHLETIC/SPORTS

Shooting advertisements for athletic equipment or garments involves a different approach than most fashion-oriented shots. These ads generally require less structured, more active shots that generate excitement for the product and for the sport.

When shooting for these kinds of clients, I usually prefer to go on location, rather than shooting in the studio. A local gym, basketball or tennis court, or high-school football field will give the photographer opportunities for action shots not available in most studios.

If the model whose portfolio you are shooting seems particularly muscular or otherwise well-suited for this kind of work, take a field trip with some sports gear and athletic wear, then experiment with active, high-energy poses.

These ads generally require less structured, more active shots.

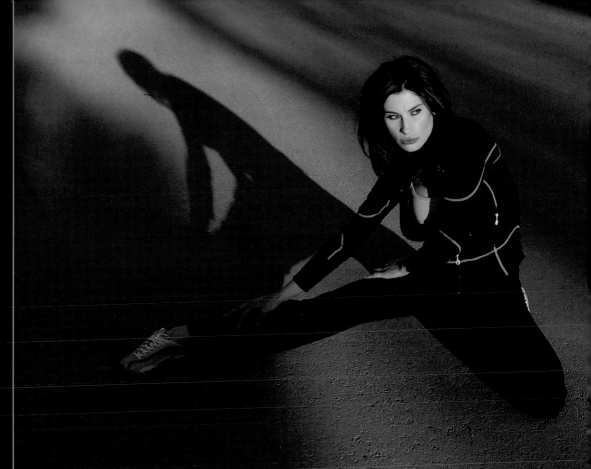

The posing for athletic and sports ads can be quite different than that found in other genres.

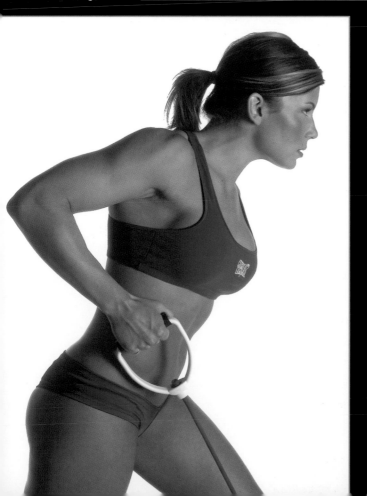

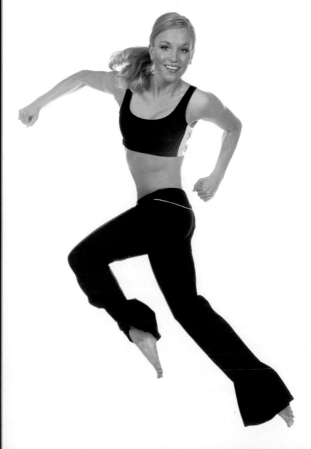

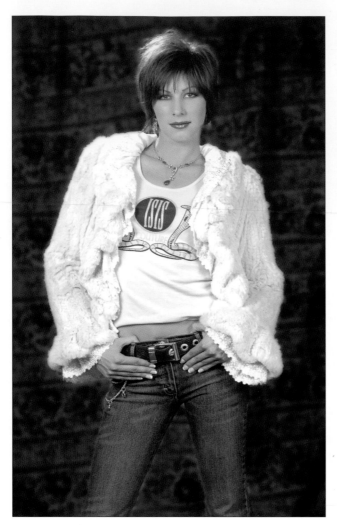

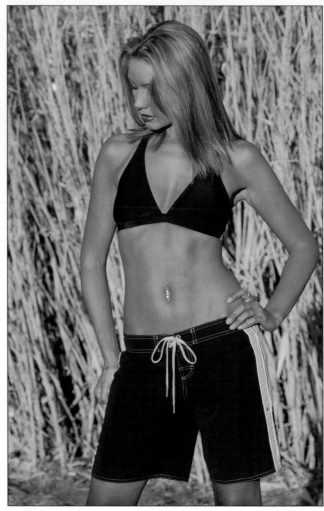

CATALOG

Catalog work refers to the images used in a retailer's catalog, mail-order brochures, flyers, and other materials that are used to sell specific merchandise. The main objective of these images is to present garments or other merchandise in a straightforward, very detailed manner. This work doesn't carry the status of editorial or advertising print photography, but it can form the backbone of a photographer's income.

For this type of work, models are selected based on their look. Generally, they should represent the ideals of the market segment toward which the particular catalog is targeted—whether it's teenagers, senior citizens, moms, businesspeople, or plus-size women. The idea is transference. "If you buy this outfit, you will look as wonderful as our model does!"

Catalog shoots often involve more than one model per shot—and each model is expected to be able to show the garments to an advantage. In the section on feet that appears on pages 38–44, we looked

Catalog work is designed to display the garments or other products that the retailer is offering for sale.

at three basic foot positions. These are often used in catalog shots, where you have three models in a shot and each is posed in one of the three basic foot positions.

While catalog shoots don't carry the status of editorial or magazine ads, the current trend in this genre is actually toward more exciting, artistic, and interesting poses. Of course, you must still stay within the needs of the specific client.

SWIMWEAR

Exotic locations, white sand beaches, soft breezes, and palm trees—these are key ingredients when shooting swimwear. The very nature of this market demands exotic beauty. In this genre, the line between fashion and glamour softens. As such, the models for this line of work tend to be more curvaceous than those seen in straight fashion photography. Swimwear models can also be shorter than fashion models. The bottom line in this market is transference—the general public wants to feel that if they buy this swimsuit, they too will be hot, sexy, and beautiful.

Picturesque beach locations are common in swimwear images.

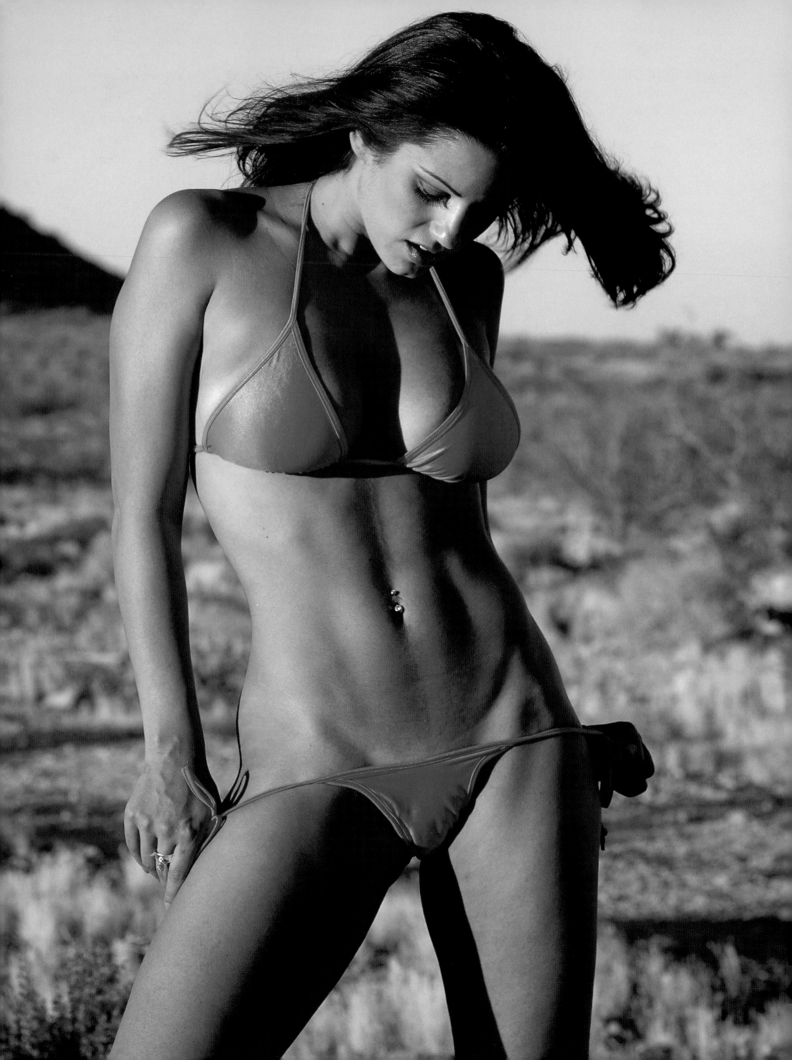

FACING PAGE—For the swimwear market, models tend to be more curvaceous than in other subgenres. Without changing the basic pose, you can make the shot sexier by having the model push down her swimwear bottoms as low as she is comfortable with.

Generally, the only swimwear shots created in the studio are the line sheets that are used to present a designer's collection directly to the buyers for department stores and other retailers. This isn't to say that swimwear *can't* be shot in the studio, but doing so requires a great deal of creativity and is generally only for specific shots where the swimwear is more of a prop than the main focus of the image.

A current trend when shooting swimwear not specifically for catalog purposes is to have the model push down her swimwear bottoms as low as she is comfortable with. Visually, this adds a couple inches to the length of a model's waist, making her appear thinner in the tummy area.

ABOVE—When shooting for a client, be sure to put emphasis on items that are unique to the garment. This gives the client more possible usage for the photographs. You should also pay particular attention to any special zippers, strings, buttons, pockets, or design features.

RIGHT—Unless you're photographing a line catalog, it is not normally viable to shoot swimwear indoors. However, swimwear can be used as an accessory when creating a poster-type shot. The use of dramatic lighting combined with a dramatic pose can be very effective. In poster shots, the poses—and the models—usually look assertive, even confrontational. In this particular image, the emphasis is on the model's fitness, so her eyes are looking off camera.

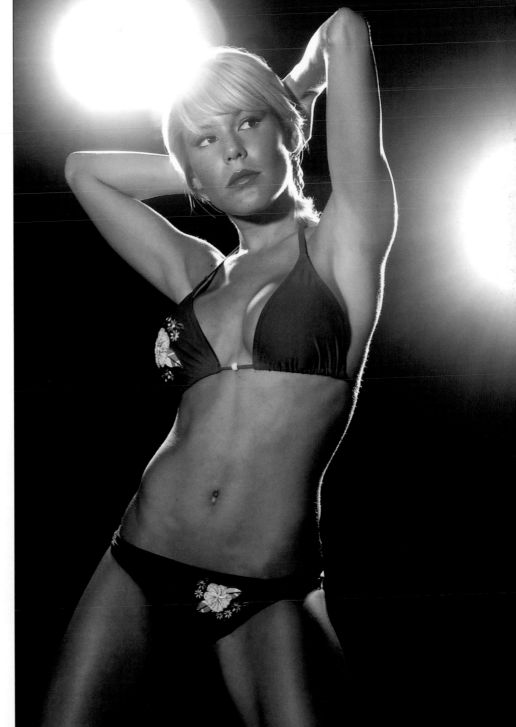

SPECIAL ATTRIBUTES

When working with a beginning model, pay particular attention to her special attributes. Many models find ample work in fields where they are called on for their beautiful hands, legs, feet, hair, or other remarkable features. If you spot something unique about your model, consider designing an image to showcase it.

I noticed how beautiful this model's legs are, so we booked a special session to emphasize them in some images for her portfolio. Here, notice the beautiful toe point, the structure of her calf, and how slender her legs appear. Less than a month after this photo was placed in her portfolio she was booked for a commercial leg shoot.

5. Practical Examples

BETHANY: BODY SHOT

Bethany wanted to create a body shot for her portfolio that showed both her flat stomach and toned legs. She wanted the shot to have an element of dance, yet not be sexual. Here are some of the images from the shoot.

ABOVE—The photographer must pay close attention to the hands. Beginning models have a tendency to spread their fingers. This creates lines that draw the viewer's eyes and change the flow of the photo.

RIGHT—This photograph is not what the client requested, as it doesn't show her stomach. However, it does show her rear and profile to an advantage, which was a bonus.

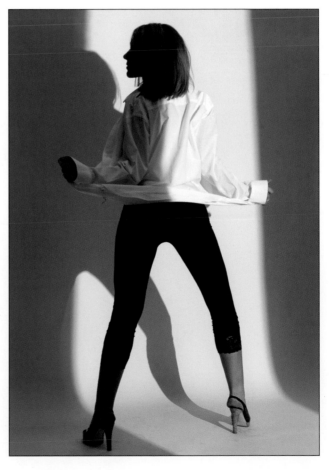

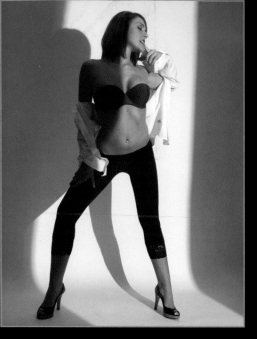
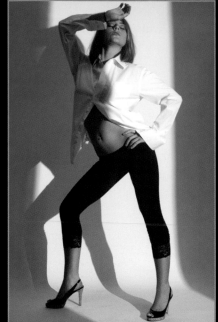
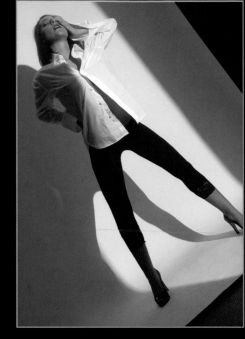

ABOVE—The lighting is the same in all three photos, but notice how a kick of the hips and the use of the hands created differences in the dynamics.

LEFT—This shot showcases Bethany's flat stomach and lean legs—just the look she wanted for her portfolio.

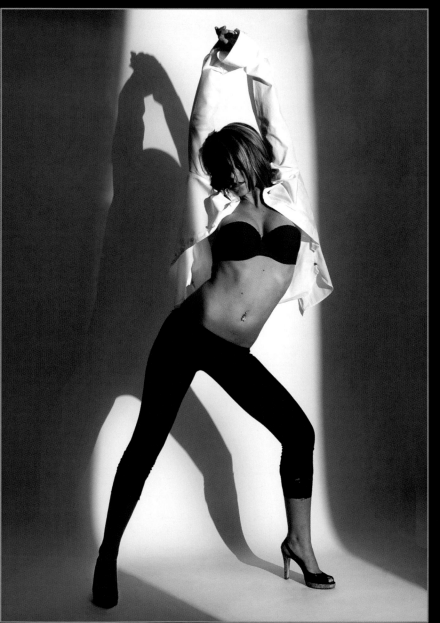

CIANA: SYMMETRY

Scientists agree that symmetry is the secret to beau[ty]
shoot a portrait of Ciana for Wendlynn & Assoc[iates]
Team, I wanted to show the symmetry of her face. [I would]
not pose her any other way but straight to the cam[era.]

The following images show some of the proble[ms I en-]
counter when photographing such a session. Ciana [has the]
experience to avoid unflattering poses; she photographed these only
for the purpose of this demonstration.

This photo is not usable; there is too much tension in the hands and the nails are pushing wrinkles into the face. The hands should frame the face without placing pressure on the skin.

The placement of the hand in this photograph is standard for many portrait photographers. However, it is unacceptable for fashion and beauty clients because it is too masculine. The hand is nearly as large as the face and commands too much attention. With the weight on the hand, the photograph also fails to communicate the grace and elegance of Ciana's face.

This photo would be acceptable in many applications. However, for this particular client, the shoulder, breasts, and area under the right shoulder strap demand too much attention; they draw the viewer's eye away from the model's hair.

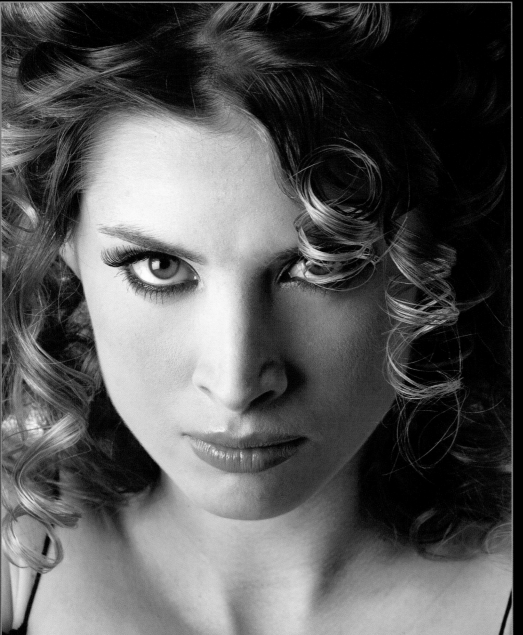

ABOVE—These are acceptable photos to many, but one must learn to effectively show a model's individual beauty. Identify what makes her unique, and then enhance those features. In this case, Ciana's shoulders and chest draw the viewer's eyes away from the symmetry of her beautiful face, neckline, and hairstyle.

LEFT—This photo is cropped too tight for use by the client. Also, it is not the most flattering crop for Ciana's face.

FACING PAGE—This photo has the same elements as the large shot on the previous page. It could be an effective photograph if you wanted to draw the viewer's attention to something on the facing page.

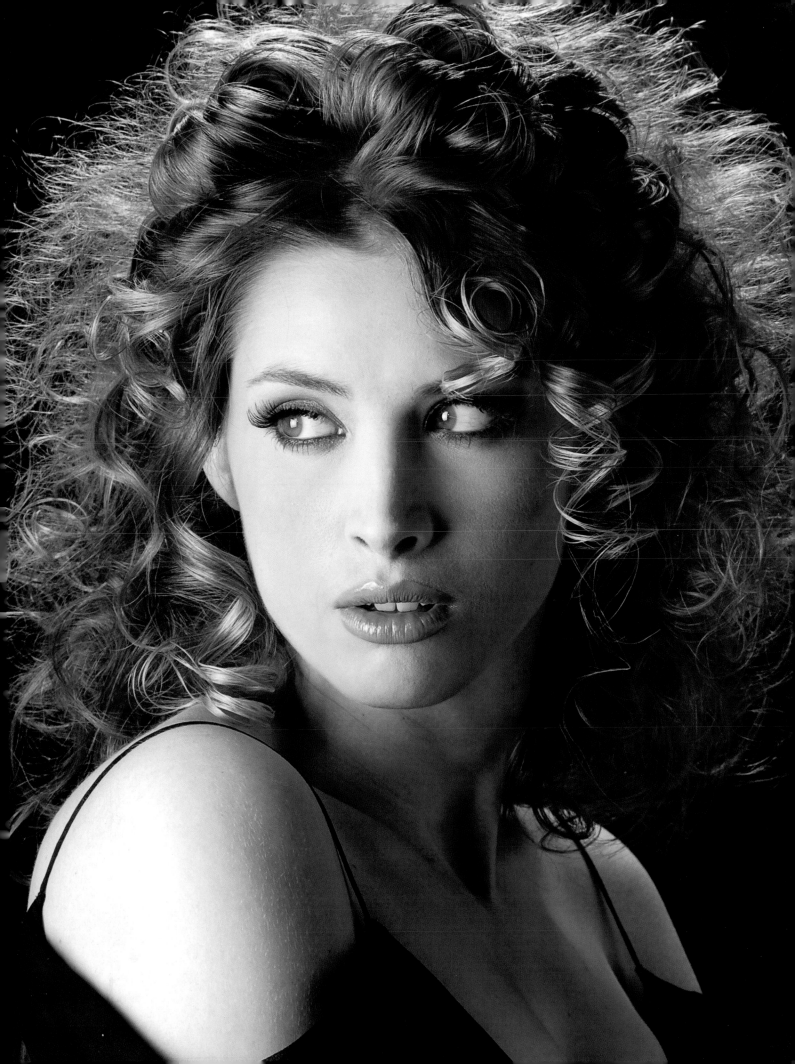

JANEEN: NATURAL CURVES

For Janeen's first photo shoot, we wanted to create a beautiful body shot that was soft and sensual. Because of the diminishing light, we had a very brief time to shoot.

Fortunately, Janeen was aware of her body and was naturally a good poser. As a result, we were able to get many good shots. Notice the beautiful use of her hands, the natural curves of her body, the variations in facial expressions, and the beautiful head positions.

When a model brings this level of movement, she makes the photographer's job so much easier. It allows the photographer to create work that can be beautiful and beneficial to the client.

When creating a body shot, have the model make only small variations in her pose from frame to frame.

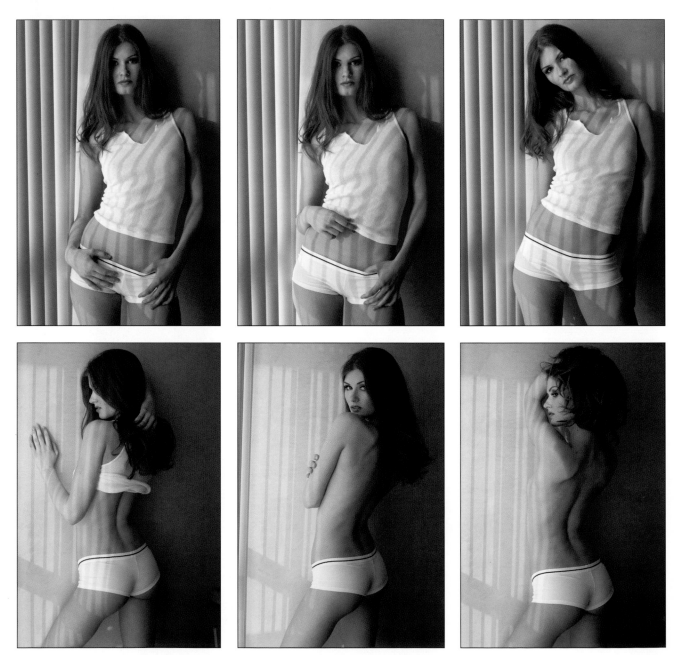

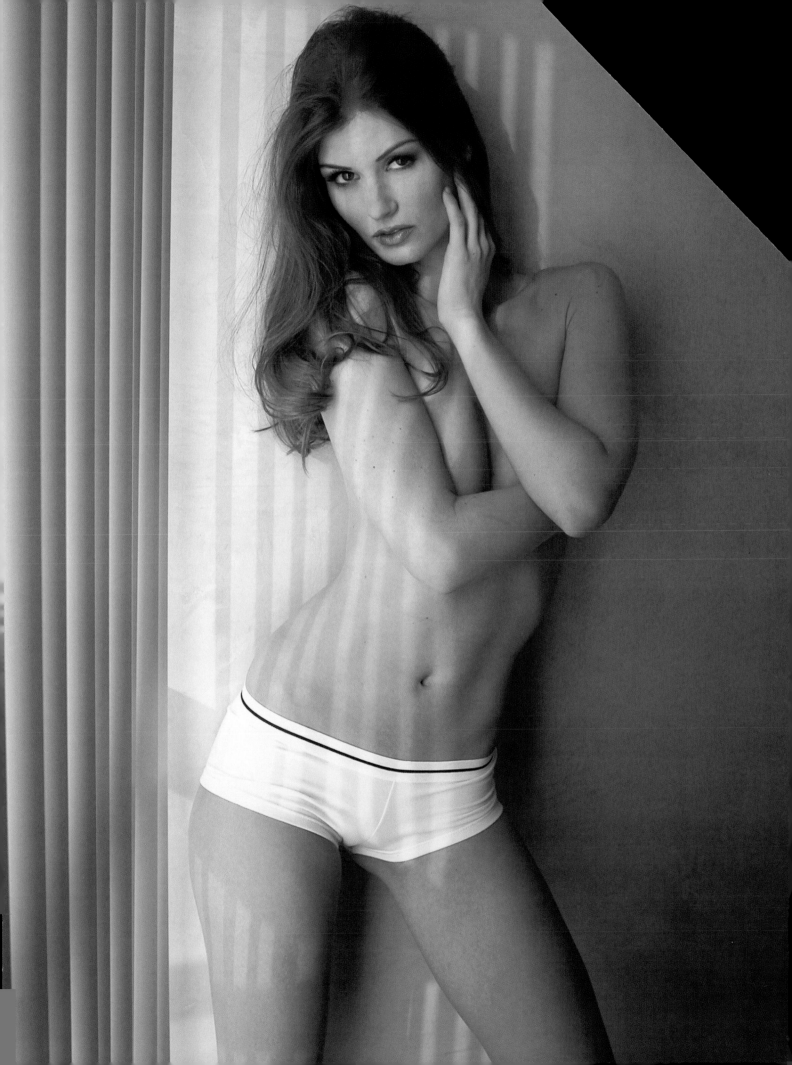

FACING PAGE—Here, Lexie demonstrates the demure side of her personality.

LEXIE: SHOWING PERSONALITY

When shooting specifically for a model's portfolio, let her personality show. If she is slender, you can be much more forgiving on the posing. This makes it easier to encourage the model to show the full range of her personality. Try to show that the model can communicate her vibrant personality without distracting the viewer from the product being sold; the demand for models with this ability is huge.

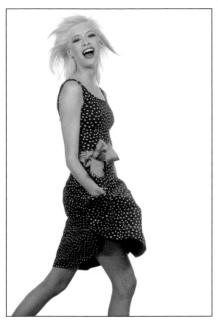
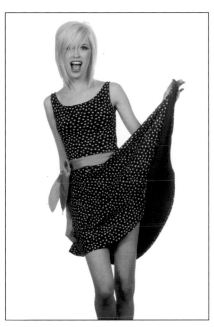
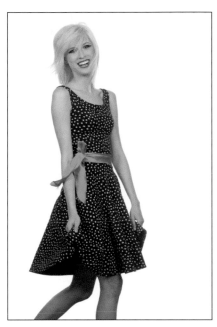

These photographs make a statement about the model's ability to show a wide range of movement and personality. She is slender and fit—and can be quite spontaneous. The ability to be upbeat and still maintain a commercial value to the photograph is very marketable.

When clients view a model's portfolio, they are more likely to hire her if the photos reveal her personality and reflect her enjoyment of her craft. Lexie's vibrant personality makes a photo session fun—and this is most assuredly a bonus.

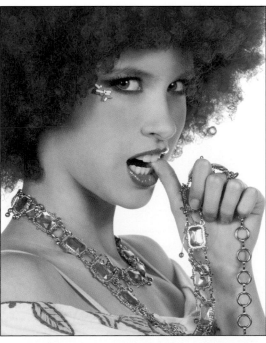
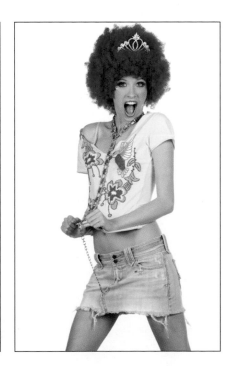

MONIQUE: GIRLY, CUTE, AND FUN

The pinup style has returned! Many clients want to create a socially entertaining and sexy marketing tool without being overtly sexual. The photographs are girly, cute, and fun. When creating this style of image, the model must understand how to pose her body. More importantly, she must have the self-confidence to act silly.

Monique was asked to pose on her knees and lift off with her thighs. This helps create a thin thigh. Whenever possible, have the model's weight resting on parts of the body that are hidden from the camera—in this case, her left thigh. She was also asked to present her chest to the camera.

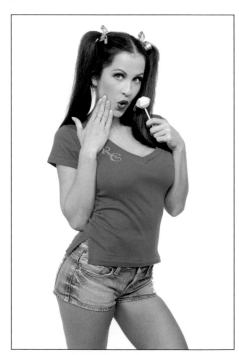

Monique was asked to jump up, create movement in her hair, point her toes, and twist her upper body back toward the camera—all at the same time. Most often, it takes many attempts to capture the desired results with a shot like this. Even if the photograph is not successful at first, though, it creates the mood necessary for the model to feel comfortable. If you can get a model preoccupied with movement, she will normally relax and start posing naturally.

The model has separated her legs and turned her hips off camera. This position visually slims her thighs. Normally, the model should not have her hand near her face and with such a wide profile. However, it works here because it looks like a natural placement of the hand for a cute, shy position.

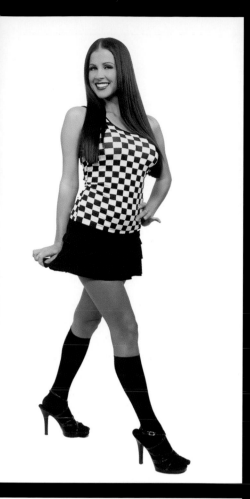

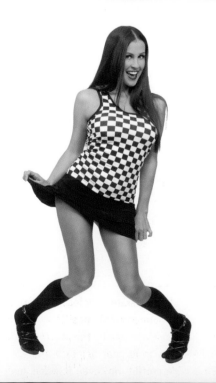

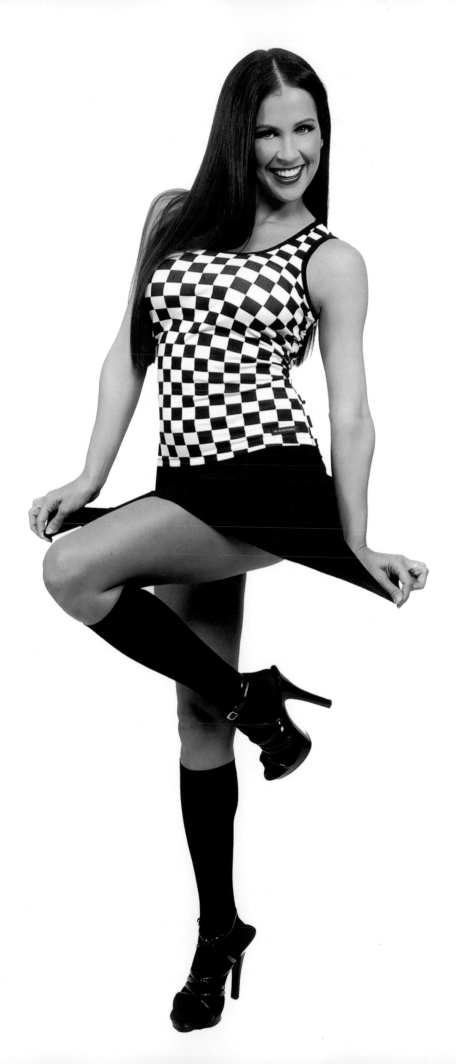

These images show several examples of body positions for high-energy, fun, pinup work. In the top and right images, notice that Monique has turned her hips away from the camera. This causes her waist to appear much thinner.

6. HINTS AND TIPS

The following are a few additional tips that will be useful to you when learning the art of posing your models. They are presented in no particular order, but each will help to facilitate the learning process.

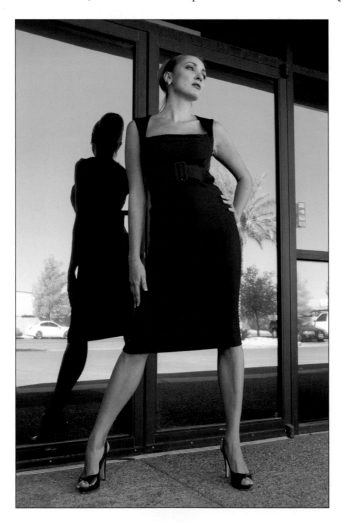
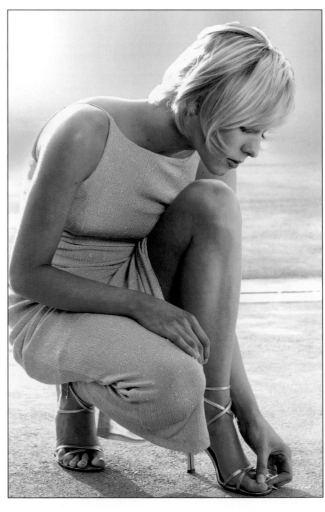

RIGHT AND FACING PAGE—Have prospective models create a sample portfolio of images (from magazines or elsewhere) in which they can see themselves replacing the model. This will help you to determine the kinds of images they are looking for.

This will show you where the model sees herself and identify her goals.

BUILD A SAMPLE PORTFOLIO

When working with a beginning model, have her build a mock portfolio of her favorite poses to bring to the shoot. Using photos from magazines, ask her to compile a collection of both headshots and full-length images that she would like to see in her portfolio—shots where she could see herself replacing the model. This will serve two purposes. First, it will show you where the model sees herself and identify her goals. Second, it will provide you a handy reference guide when posing the images you create for her real portfolio.

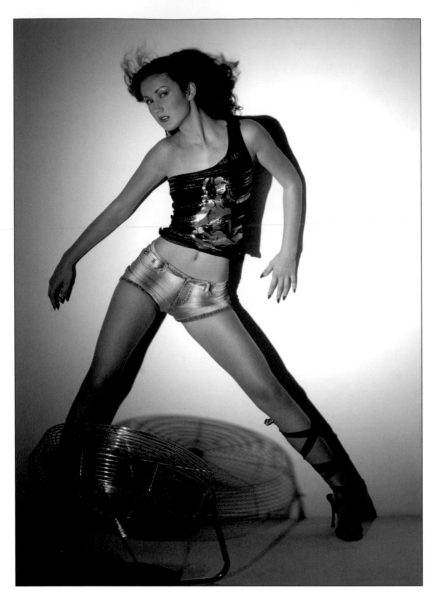

In her portfolio, the model is the product you are selling, so each image must showcase and promote her particular assets.

The construction of the mock portfolio is rarely a one-step process. I have found that the model's first grouping is often based on wishful thinking and media hype. It takes a bit of gentle guidance to teach a beginning model to look at herself realistically and develop a useful mock portfolio. However, this is absolutely necessary before proceeding with the development of her actual book.

When our team (hairstylist, makeup artist, and photographer) goes over a model's completed mock portfolio, we narrow down the images to a few looks. Then, we start planning her photo session and coordinating the clothing for each specific shot. The mock portfolio acts as a reference guide during this process.

Once you have been photographing models for a while, you can also use this mock portfolio to show the model what look you are trying to achieve in each shot. A model's job is to sell a product, article

It takes a bit of guidance to teach a beginning model to look at herself realistically.

of clothing, or a mood. In the photo sessions for her portfolio, how-ever, the model *is* the product. Therefore, the photographer and his team, along with the model, must coordinate all of their efforts to promote her particular assets.

QUALITY

The quality of photos in a model's promotional materials must be exceptional. Many agencies would rather see snapshots than poor-quality professional photos. Before every shoot, ask yourself what part of the model's "product" you are showing—physical beauty, legs, lips, sensuality, etc. If you are not totally confident in your ability to pro-duce top-quality images, be fair to the model and take a pass on the job while you continue your training.

INFORM THE MODEL

Talk to the model and try to explain the feeling and flow of the pho-tograph you are creating. A continuous dialog is essential. You must

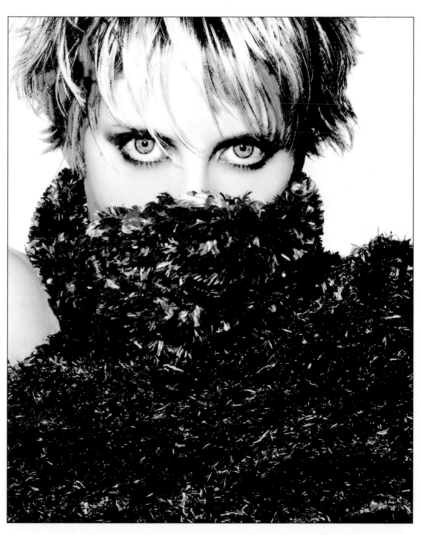

A continuous dialog is critical when shoot-ing. This ensure that everyone is working to-ward the same goal.

make the model feel comfortable, using praise and encouragement to expand her confidence and help her project the required moods.

Be positive in all suggestions you give to your models. If you need to shift gears, saying something like, "Enough! We need to try something else," is only going to shatter her confidence. Instead, try saying, "That was great. Let's shoot a few more images like this, then change the mood." By asking the model to try a few more images, you're letting her know that she was doing what was required, but now you want to go in a different direction. No negative message was communicated, so you've left the model feeling positive and ready to work with you on the next look.

If your model is struggling, try asking her to imagine herself playing a character. The best models are not just beautiful, they are also versatile. The ability to get into a character is a very useful asset for a model to possess.

BEGIN WITH PORTRAITURE

In this business, it takes a long time to get established, so be prepared to go the distance if you want to achieve success. You will also need a great deal of photographic knowledge to prepare yourself for all the demands of lighting, posing, etc. You'll need to become knowledgeable about makeup, hair, and clothing styles, plus you'll have to learn to work with and instruct people. All this knowledge needs to be gained before starting out as a fashion photographer. If you start shooting as a fashion photographer before you have gained the expertise needed, you can easily blow an assignment and give yourself a poor reputation.

Therefore, I recommend that you get started as a portrait photographer, where you can practice your skills in a controlled lighting environment and learn how to quickly establish a rapport with people. Don't feel you'll be limited creatively by the "portrait" genre; the images of many fine portrait photographers are really fashion/commercial images, because their clients want creative images that reflect the looks they see in their favorite magazines.

Using lighting, composition, and design, each photographer—whether portrait or fashion—will create their own style. The portrait specialist, however, can use the same style, or combination of styles, for many sessions—or even for years. This can be a great asset when you are getting started, since it allows you to become comfortable with the photography process and working with your subjects without the constant pressure to produce a totally unique image every time.

FACING PAGE—Helping a model project the required moods means building her confidence and always maintaining a positive attitude on the set.

Practice your skills in a controlled environment and learn to establish a rapport with people.

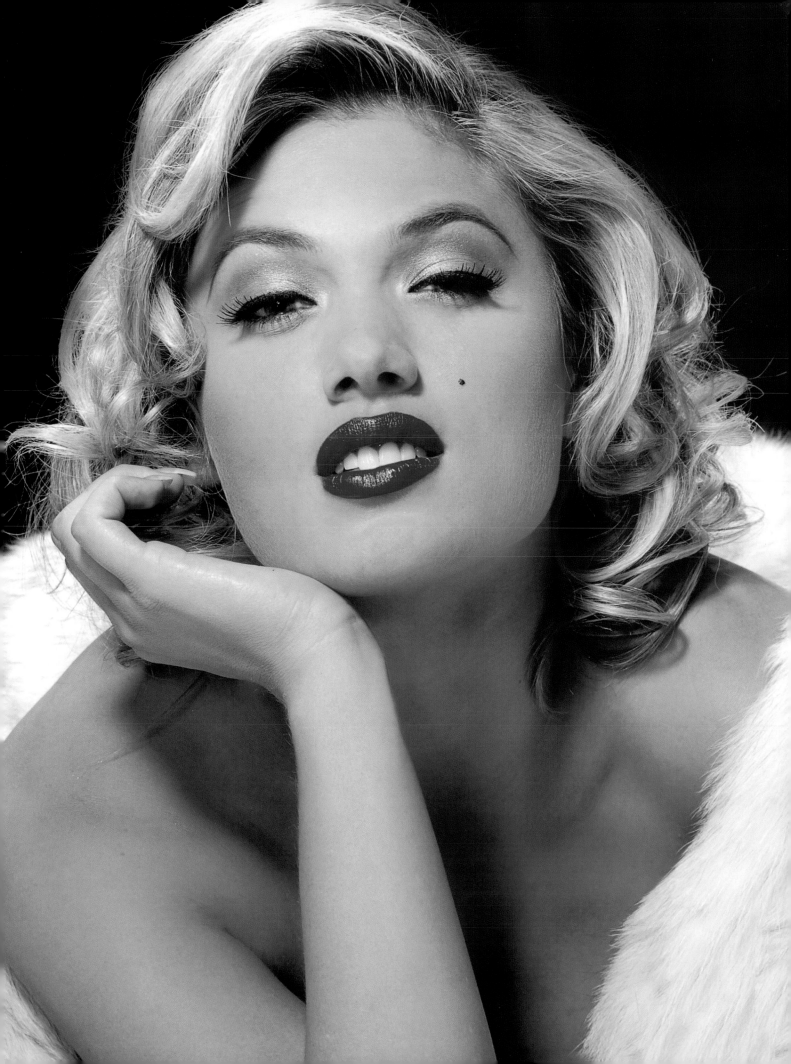

Fashion photographers, on the other hand, must constantly change their style. Many fashion specialists may have shooting tendencies (e.g., use of grainy film, bright colors, tilting the camera off axis, etc.), but they must be able to adapt quickly to each client's needs or they will eliminate many potential accounts. This versatility is what allows the fashion business to change rapidly and go in entirely different directions each season. As you become comfortable with the process of creating portraits, therefore, you should not become complacent. It is important that you challenge yourself to design and execute self-assignments that will teach you additional lighting techniques and fashion styles.

Develop your own style slowly, and don't accept clients or jobs you are not totally comfortable in handling. As you progress, you can develop a team of hair dressers, makeup artists, and clothing stylists to give you the best-possible chance of creating great images.

Fashion photography is always evolving, and photographers must be able to adapt quickly to each client's needs.

CREATE A MOOD

Imagination is a wonderful tool. Ask a model to imagine different scenarios to create a mood. For example, pretend to be shampooing her hair under a tropical waterfall. Also, don't discount the possibilities offered by fun and flat-out funny images. These can create a lasting impression on the model's prospective clients.

THE MODEL'S COMFORT

An important thing to keep in mind when photographing models (especially inexperienced ones) is to make the shoot comfortable for them—after all, being in front of the camera can be intimidating for anyone. I love helping models build the confidence they need to be at their best on camera. I do this by focusing on their strengths and getting them pumped up about the shoot.

I also use stories to make it clear to them that being in front of a camera

Fun and funny images create a lasting impression with commercial clients. Notice how much humor is used in TV commercials.

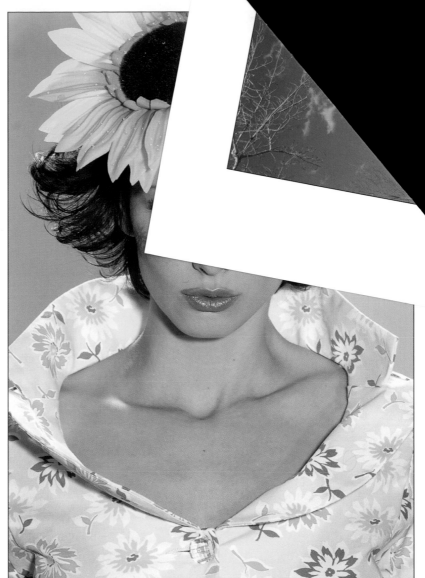

in the studio isn't like being in front of Mom's camera at a picnic. One of my favorite stories is about a *Sports Illustrated* swimsuit photographer who shot *forty-thousand* pictures on location to get *sixty* for print—and that was with a full makeup and hair crew, photographic assistants, and professional models! The lesson? Not every photo has to be perfect.

In a portfolio session or on a glamour shoot, it also helps to remind your models that no one will see the photo before them—so if they hate an image, they can choose not to use it. Of course, this is not true for professional shoots, where models normally won't see the photos until they are published.

Constant reinforcement of a positive nature is very important throughout the whole shooting process. Many models wait to hear positive feedback before they proceed to the next pose.

Athletic images usually make the most sense when shot against outdoor backgrounds. In a studio setting, a plain white background is the best choice.

BACKGROUND SELECTION

Look for unique locations that will make your model's photographs stand out from the rest. For example, if the model is looking for work in Asia or Europe, try to include some photos that couldn't be made there because they include features that are unique to your area. This could mean including characteristic architecture or landscapes, or anything else you can dream up.

Backgrounds can be as simple as white seamless paper or as complex as a crowded city street. They can be classic or contemporary, subtle or bold. But whatever type of background you choose, be sure to use poses and clothing that either match its character (a woman in a stylish suit on a busy city street) or contrast with it wildly (a woman in a formal gown in the desert).

Most of all, the background should flatter the model and be used in such a way that it doesn't compete with her for attention. If a background seems distracting, try throwing it out of focus by posing the model farther away from it.

CLOTHING

When shooting images for a model's portfolio, I have her bring a lot of clothes to the studio (better too many than too few!). The clothes you finally decide on should be ones that are not too trendy. Clothes like these will look dated quickly and require more photographs be taken. Once a model is well established, she can add more trendy items to her portfolio. For the amateur model, try to accomplish a few basic shots: a basic head shot, a glamour head shot, a basic full-body shot, etc. Try to show the model's beauty with a clean and fresh look instead of a highly stylized one.

If a background seems distracting, try throwing it out of focus.

When the clothes are an important part of the image, make sure that they fit properly (or at least appear to). Fit problems occur frequently and have to be worked around. You can use clips behind the model to pull clothes tighter if they are too big, or you can pose the model in some way that disguises the poor fit—but you have to do something. Otherwise, neither the clothes nor the model will look as good as they could.

Clothes can also be the source of inspiration for an image, so don't think of them only in terms of an accessory. When a unique, appealing, very flattering garment catches your eye, think of ways you could build an image around it. Think of backgrounds and poses that could be used to highlight what it is about the clothing that particularly appeals to you.

Unless the clothes are the reason for taking the image, they should not take the viewer's attention away from the model.

LIGHTING

Lighting is one of the most versatile tools in the photographer's arsenal. The majority of new fashion looks are created in the controlled environment of the studio, the place where the photographer has the ultimate control over every aspect of the photograph. When you are working in the studio, strive to use your lighting in ways that most flatter the subject, emphasizing her best characteristics and minimizing any problems.

If you are still working toward mastering studio lighting, try scheduling your shoots during the "golden hours," the hour just after dawn and the hour just before dusk. During these hours, the light is warm in color and gives the skin tone a beautiful glow. Also the light is low on the horizon, so it will not cause the shadows on the model's eyes that are seen with unmodified sunlight at other times of the day. This means that you can work without the need for fill flash or reflectors, giving you more time to focus on your posing and background selection skills.

There are countless books on photographic lighting on the market that can be of great use as you build your skills. Several of these are listed in the last pages of this book, but you can find more at your local library or online.

CREATING A PORTFOLIO

A model's portfolio should typically have between twelve and twenty photographs—enough to show versatility, but not so many that a potential client will lose interest. A portfolio should be structured so that it shows all of the model's strongest attributes (her legs, hands, swimwear figure, beauty, etc.). It is better to have a few photographs that really show off the model than to dilute the overall quality of the portfolio with weak pictures. If you include only the model's strongest images, you'll leave viewers with the impression that every time this model shoots, she has great photos.

Opening and Closing Shots. Your model's best shot—or the one you want the viewer to remember—should be placed as the opening photo in the portfolio. If one photo doesn't seem to dominate, then use the model's best head shot. At the closing of the portfolio, use the second strongest photo, or one that is similar to the shot you selected for the opening.

Arranging the Interior Images. The best way to arrange the interior images of the portfolio is to take all of the photographs out of the book and lay them on the floor. Then, begin grouping them and arranging them into patterns that seem to flow naturally from one photo to the next.

Grouping. When you group similar images together, the viewer's eyes will scan for the differences—for example, a different facial expression. Keep in mind that images don't have to be from the same shoot to work well together. The photographs could have other qualities that link them, such as a similar theme, background, or color.

Stuffing. If you separate photos from the same shoot, it will look like the model is "stuffing" her book. The viewer will feel disturbed, thinking he has seen an image before. The only time it is appropriate to separate similar images is if you are using one for the front page and one for the closing page. In this case, the separation lets viewers know that they have reached the end of the model's portfolio. It also reminds them of the opening image and encourages them to review the images they have just seen.

Blank Pages. If you place two unrelated images next to each other, they may compete and cause the viewer to lose sight of each individ-

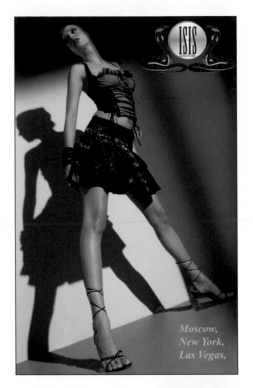

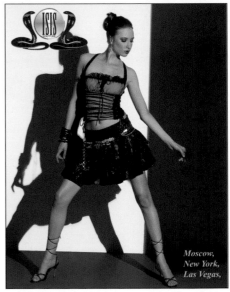

When the viewer is presented with two similar images, they look back and forth between them to study the differences.

ual image and just notice an unbalanced feeling. If you don't have two images that seem to flow well together, then leave one page blank. The blank page will force the viewer to really look at the single image.

VARIETY

A model should show the work of several photographers in her portfolio; each photographer has his or her own style and can add variety to the book. Also, a model's portfolio is never finished. She should always be adding and subtracting photos as styles and seasons change. If her career takes off, she will someday replace all the photos in her book with work from paid jobs (called "tear sheets").

To be truly successful, models need to show a wide variety of images in their portfolios. This means that they need to work with a number of photographers.

In Closing

The career of a fashion model is heavily dependent on the participation of the photographers she works with. Many supermodels even credit their relationship with a particular photographer as being critical to their career.

While there are many skills that will help you to establish your reputation in this field, really understanding how to pose a model to make her look her best is one of the most critical. Even with the best lighting, the most gorgeous clothing, and flawless makeup and hairstyling, an image in which the pose looks awkward or unflattering will never be a success.

In this book, we've looked at a variety of posing strategies, techniques for positioning each area of the body to best effect, and how to combine the various elements of a pose into an image that suits the market in which the model wants to find work. The next step is to put these techniques into practice. If you have a photogenic friend, try scheduling a test session in which you'll focus on honing your posing techniques. Or if you are already working as a portrait photographer, consider adding a few "fashion" poses to your portrait sessions—if you are successful, your clients will undoubtedly like the results!

Ultimately, I encourage you to approach model photography as a learning experience every day—and thank yourself for choosing a job in which the immeasurable rewards include the opportunity to have fun and be creative.

Consider adding a few "fashion" poses to your portrait sessions.

FOR MORE . . .

For more information on Billy Pegram or to see more of his images, please visit www.billypegram.com.

Index